INFORMALLY
ROYAL

BY THE SAME AUTHOR

Houses and Gardens of the English Countryside: A Book of Days

The Illustrated International Traveller's Companion

Winter Wellies
(a book for children)

To Hell with Poverty

A Darracq Called Genevieve

INFORMALLY ROYAL

STUDIO LISA
AND THE
ROYAL FAMILY
1936–1966

RODNEY LAREDO

The History Press

First published 2019
This paperback edition first published 2021

The History Press
97 St George's Place, Cheltenham,
Gloucestershire, GL50 3QB
www.thehistorypress.co.uk

© Rodney Laredo, 2019, 2021

The right of Rodney Laredo to be identified as the Author
of this work has been asserted in accordance with the
Copyright, Designs and Patents Act 1988.

Front cover image © Getty Images
Other images © the author except where stated otherwise

British Library Cataloguing in Publication Data.
A catalogue record for this book is available from the British Library.

ISBN 978 0 7509 9803 1

Typesetting and origination by The History Press
Printed in Turkey by IMAK

CONTENTS

For Alethea, Claire and Andre

ACKNOWLEDGEMENTS

I am indebted to Pat Chambers, who when just 18 years old, in the late 1930s, joined the staff of Studio Lisa in Welwyn Garden City where she subsequently lived for much of her life. Pat's encyclopedic recollections of working alongside Lisa and Jimmy Sheridan and indeed her knowledge of Welwyn Garden City then and as it expanded over the years knew no bounds.

I was introduced to Pat by Dinah Sheridan, who fully supported the idea of *Informally Royal* back in 1990 and without whose input this record could not have been adequately researched. Dinah and I had enjoyed a friendship of more than four decades before her departure from this world aged 92 in 2012. During those years she often shared with me memories of her parents' photographic life from the earliest beginnings through to worldwide acclaim. Dinah's various accounts, plus the sharing of her own archives, and those of her mother and father, now woven into this book, have a special solo significance given that her mother and father had long before predeceased her, as had her older sister Jill, who died suddenly at the early age of 48, six months after their mother. I am indebted to the recorded memories of Jill's son Tony Reeve, as I am to the assistance of Sarah Grant and Andrew Lannerd.

My thanks are also due to Charles Beale former managing director of Studio Lisa during the years when Lisa Sheridan, after her husband Jimmy's passing, still retained an active interest in the photographic business that bore her name. Meeting Charles in the studio's Grape Street days, before his retirement, afforded me a valuable insight into the early pictorial records of Studio Lisa.

Likewise I appreciate the input from Don Chapman, a former managing director of the picture agency Camera Press. He wrote to me

at length concerning his personal business dealings with Studio Lisa over twenty-five years ago, when the idea of this book was first being discussed.

Matthew Butson of Getty Images has been unstinting in his support for this book when it was always just a prospect and not much else.

The assistance of both Getty Images and Camera Press, who are joint owners of the Studio Lisa Royal Photographic Collection, is gratefully recorded.

I record with appreciation the friendship and hospitality extended to me and my wife by Jean Tindall in Welwyn Garden City.

My thanks are extended to Ted Gatty, formally of 'Castle House' Broadstairs.

Also noted here is the enthusiasm and guidance for this project from my editor Mark Beynon at The History Press.

I acknowledge Joy McGregor, who painstakingly typed the first draft of my original manuscript. Most especially to my wife Alethea, who checked and corrected time and again my research notes, and kept me on track, my heartfelt recognition is extended as always.

Of immense help to me was Lisa Sheridan's autobiography *From Cabbages to Kings* (Odhams, 1955), as were the numerous published collections of Studio Lisa's royal sittings throughout the years.

Every acceptable and reasonable effort has been made to locate likely copyright holders of material referred to in this publication. The author and publisher regrets that which remains unattributed including any references inappropriately recognised. Future reprints will rectify omissions.

AUTHOR'S NOTE

As a photographic establishment Studio Lisa no longer exists, yet the many hundreds of royal photographs taken between 1936 and 1966, bearing the Studio Lisa insignia will always be invaluable in documenting royal history.

Since the closure of the studio, its royal photographs have never ceased to be reproduced in one form or another. Regrettably however, the accreditation 'By Studio Lisa' is seldom used now; the names of the photographic press agencies that currently own and supply the images in question accompany them instead.

Although it has taken more years than it should have for the record to be redressed, this book brings together for the first time a diverse selection of Studio Lisa's famous royal studies, with others not so familiar that were taken over the thirty-year period portrayed in the following pages. In so doing, there should be no doubt in the minds of present and future generations of royal pictorial collectors as to the photographs origins and who was responsible for them.

PREFACE

'Why do you do it?' 'Why is it that you never let up on the pace of your working day, this boundless enthusiasm, this quest to fill each hour with something new, such energy that leaves no stone unturned?' These were questions often asked of Lisa Sheridan.

'Because,' she would reply, 'because I like a little lace on my petticoat.'

Lisa Sheridan was the consummate enthusiast, an enquiring individual of whom an interviewer once said: 'She is probably more at ease in the presence of Her Majesty The Queen than almost any commoner in the world.'

She had little time for more languid souls who found life a dirge and was essentially a progressive person, ahead of her time in so many ways.

With her husband Jimmy, Lisa turned their shared interest of photography into a profession of distinction, becoming celebrated throughout the world as Studio Lisa, photographers by appointment to Her Majesty Queen Elizabeth The Queen Mother, from whom they held a Royal Warrant.

As a team their enormous success evolved from an appreciation of each other's skills. It was an innovative combination of her flair and intuition and his technical expertise that allowed the Sheridans to capture the Royal Family with an air of informal domesticity rarely seen before by the public at large.

For example, choosing outdoor locations in set-piece portraiture was a risky departure from the norm, particularly during the 1930s and '40s, but as a result the Royal Family became less remote to ordinary people. Such a closeness between monarchy and the masses, illusory though it may have been, nevertheless underlined the importance of the inventive, albeit more casual approach to photography that became Studio Lisa's trademark.

In 1964, six years after Jimmy's death, a second royal warrant for photography was awarded by Her Majesty Queen Elizabeth II, thus making Lisa Sheridan the only photographer in the world at that time to hold the Queen's warrant while also retaining the right to use the coat of arms of Queen Elizabeth The Queen Mother.

Lisa Sheridan was the instigator, the driving force behind the studio that bore her name, but, as she readily admitted, hers was not a technical talent. She neither understood nor cared much about that side of the work, where her husband excelled. Once a scene had been set satisfactorily, a quiet 'now' to Jimmy was enough to secure the moment.

Composition was Lisa's forte: the ability to *see* a photograph entwined with an uncanny knack for manipulating light and shade. Such artistic flair was eclipsed only by her ability to relate to people, particularly her subjects. From them she could extract the magic ingredient that would ultimately make or break the final photographic result.

Despite her undoubted success, Lisa remained endearingly modest about her achievements. These included ten illustrated volumes on the Royal Family, two children's books, numerous radio plays, an autobiography, one illustrated manual on the art of photography, plus numerous articles for a variety of periodicals and journals.

In 1965, the last year of her life, Lisa told a journalist, 'I've never admitted to anyone before, but it's quite true, I really don't like photography. It's rather phony I think. I don't like photographers much either; they're so conceited, I'm inclined to avoid them.'

In her view the real joy was not so much in taking photographs but in the pleasure one got in seeing things all day long with a trained eye. Photographs, she argued, 'were really just the dead tissue of a living thing'. Acquiring an eye for seeing things as they really were led her to develop a sort of dissatisfaction with photography. She reasoned, 'Being successful at it on the other hand required a rare personality who could be both practical and artistic – an unusual combination.'

Right up until her death in January 1966 at the age of 72, the days were never long enough for Lisa. She wrote plays and books, visited art galleries

and exhibitions, helped out with Meals on Wheels and entertained while continuing to juggle visits to her London studio.

Her autobiography *From Cabbages to Kings*, published by Odhams Press in 1955, carried the dedication 'To Jimmy my husband and partner without whom Studio Lisa could not have been built and who so good naturedly has been willing to take a back seat in these memoirs.'

While *Informally Royal* also concentrates on Lisa, it must be remembered that success for both Jimmy and his wife had been gained and shared in equal proportions. Jimmy Sheridan's unobtrusive, yet quite outstanding contribution to the illustrated contents of the following pages, should likewise never fail to be appreciated.

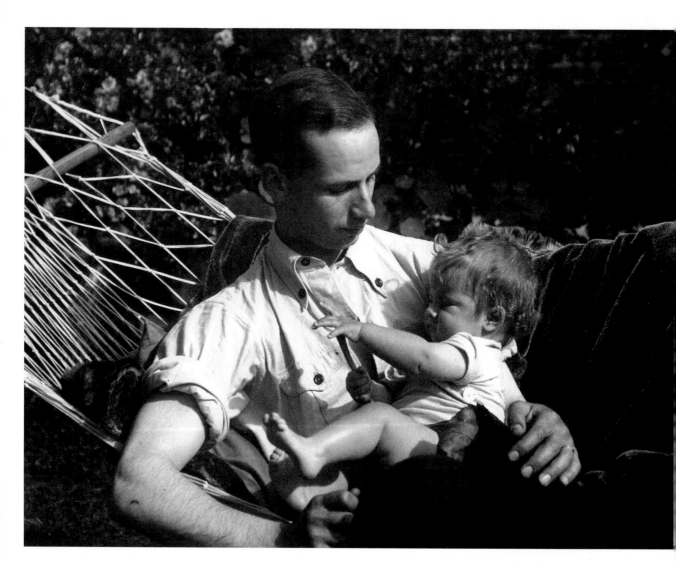

An early study by
Lisa of Jimmy with
Jill in Hampstead,
summer 1918.

THE STORY OF STUDIO LISA

From Russia to Broadstairs

Although born at Kew in London in 1893, Lisa Charlotte Everth spent much of her childhood in Imperial Russia where her family owned cotton mills in St Petersburg. They were well connected and enjoyed a sociable friendship with people such as Prince Griesha Volkonski and his wife Princess Sonia who was related to Tolstoy.

When Lisa was 11 years old the princess took her to meet Tolstoy whose home at Yasnia Polyana near Moscow was not far from Kasnia, an estate owned by the Volkonskis. The old man, already a legend, left little impression on the young schoolgirl, who regarded the introduction as something of an intrusion upon a holiday already short on time.

Members of the British colony in St Petersburg enjoyed the luxury of sending their children home to England to be educated. In Lisa's case this culminated in the study of child psychology at London's Froebel Institute, after which she returned to Russia for an extended holiday and to prepare for her coming out into St Petersburg society. Following this fashionable event, Lisa spent some months engaged in hospital work alongside the Tsar's daughters, the Grand Duchesses Olga and Tatiania.

With the First World War in its early stages and portents of the forthcoming Bolshevik revolution hard to ignore, life in Russia became increasingly unsettled. As a result Lisa hastened to England by way of a sea

passage from Archangel in Russia's frozen north to Newcastle-upon-Tyne on the north-eastern coast of England. She encountered Rasputin on the railway platform at Vologda during the train trip to Archangel, but her journey was to prove memorable in more ways than one.

As the voyage got under way, Lisa unexpectedly renewed an acquaintance with a young man of her own age, James Mec. They had met twice before, very briefly. The first occasion had been at a dancing class in Berlin when they were 10; the second was eight years later at a ball given by the British ambassador in St Petersburg. Now, at his parents' request, James was also bound for England.

It seemed as though destiny had intended them for each other. James had been born in Osaka, Japan, where his father worked in his brother's business victualling the Russian fleet, including the Tsar's yacht, *The Standart*. When he was 9 the family decided to make their home in Russia, where they had ancestral connections.

Upon arrival in England, James (or Jimmy, as he would be known) enlisted immediately. Without delay he was despatched to France to join the French Foreign Legion. Lisa accompanied him and they were married in Paris in 1914.

Departing swiftly from Russia had meant leaving behind virtually all they had owned. What little they possessed of any appreciable value was quickly surrendered in the French capital for a pathetically poor financial return. Money, or lack of it, was weighing heavily on their minds. During this period the young married couple decided to adopt the new surname of Ginsburg.

A tiny flat was found on the left bank of the Seine in the old Latin Quarter. It was here that the outgoing, vivacious Lisa set about establishing the first of several happy and inviting atmospheres that would become synonymous with the homes she would share with the gentle and good-natured Jimmy.

The yellow front door of their minute home was seldom closed. Lisa's favourite colours would always be yellow and white; to her they spelt gaiety and brightness, reflecting the mood she created for herself and her husband plus their numerous friends, who like them were also refugees.

THE STORY OF STUDIO LISA

After he was badly gassed, Jimmy was invalided out of the war in early 1917. If this wasn't reason enough for returning to England, the fact that the couple were expecting their first child certainly was, particularly as France claimed that any boy born on French soil was automatically French and must ultimately serve his country.

Back in England with the princely sum of three shillings and sixpence in their pockets, Lisa and Jimmy found a semi-detached cottage in Eastholm, Hampstead Garden Suburb, within the north London Borough of Barnet. It was a relatively new residential area, purposely laid out, designed

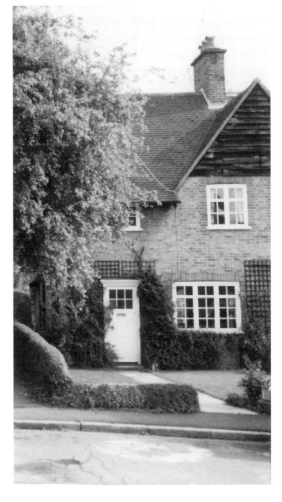

32 Westholm, Hampstead Garden Suburb.

and built to meet housing problems of the day, giving working people the opportunity of living in a cottage with a garden and a twopenny train ride into central London.

Dame Henrietta Barnett, a cosmetic heiress turned social worker, was behind the development, with the support of Raymond Unwin a mining engineer who became an architect. He had already brought his arts-and-crafts style of construction to the new town of Letchworth Garden City in Hertfordshire before focusing his attention on Hampstead Garden Suburb. The red-brick dwellings in Eastholm with their white-painted neo-Georgian windows and doors would be an early foretaste of a similar design style earmarked for Welwyn Garden City – a town destined to become synonymous with the future Studio Lisa.

It was in Eastholm that the couple's first child entered the world. She was called Beryl Jill but was always known by her second name. Jimmy, meanwhile, with no profession to fall back on, had become a travelling salesman for a kitchen gadget company. In

his absence during the day Lisa, like most young mothers, found herself totally absorbed by the rapid growth of her baby daughter. Little Jill's mannerisms changed almost daily, and her mother's natural instinct to capture these fleeting moments became something of a preoccupation.

At one stage, whilst he was near the Somme during the war, Jimmy had happened to pick up a discarded camera from the gutter. On its side was a small brass plate engraved with the name of the retailer in Nice from whom it had been originally purchased. That camera became the means by which Jill's early growth could be recorded for posterity. An extremely limited knowledge of photography combined with a dire financial predicament meant that Lisa and Jimmy could allow themselves only the occasional snapshot. Each photograph, therefore, had to be thought out and recorded as precisely as possible.

In the evenings, when Jill was tucked up in bed, the little family's small suburban home was turned into a shambles. The bathroom became a makeshift darkroom where, when extra cash could be found, a rare film was developed. The negatives were then pegged to a piece of string strung from one side of the living room to the other and left to dry.

As she sketched on paper the scene intended to be photographed, Lisa became acutely aware of available light, particularly the softness of early evening and how it could enhance or detract from the end product. Her subsequent ability in the use of light and shade became unique – the hallmark, in fact, of images to come from Studio Lisa.

By 1920 the family had moved two roads away to 32 Westholm, where in September of that year a second daughter, a sister for 3-year-old Jill, was born. Dinah's arrival reinforced her parents' desire to capture the interaction between their two young girls – moments that would never return.

As early as the second day of Dinah's life, the new baby was posed in the arms of her older sister as the pair sat in the autumn sunshine against a warm brick wall in their back garden. There were many experimental shots recorded in and around the setting and garden of the Ginsburgs' semi-detached cottage in Westholm. Its no-through-road situation and garden plot in the middle of a streetscape known as 'The Bun' made for a safe environment for the children to play in.

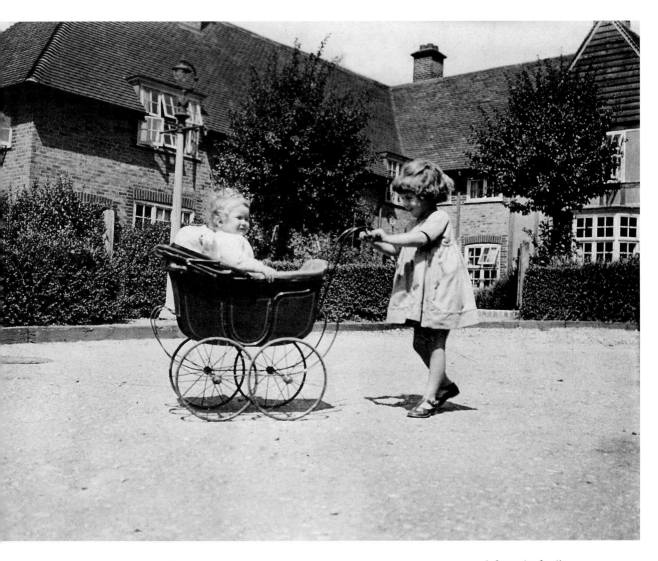

A favourite family
image of Dinah
being wheeled by Jill
in Westholm 1921.
It has a rare 'Lisa
Ginsburg' stamp on
the underside.

Following her 5th birthday, Dinah suffered a lengthy spell of ill health. Sea air was advised as a first step toward recovery; the family were consequently somewhat startled when their doctor suggested that a complete household shift to the Dickensian seaside resort of Broadstairs in Kent might suffice.

A change of address had not been contemplated let alone budgeted for. Broadstairs meant commuting. The added financial strain of this alone had to be seriously considered. Nevertheless an initial waterfront flat was found in Victoria Parade overlooking the semi-circular Viking Bay, where in time to come Jill and Dinah, with newfound friends in tow, found a playground like no other on the sands and in the sea. In due course a bigger home with more space became a requirement. This was found in the form of three-storey Castle House, tucked away at the end of Serene Place, a short cul-de-sac still close to the sea, at the bottom of Broadstairs High Street. In decades to come this home would be lived in by pantomime actor Ted Gatty, who laid claim to inventing the name Danny La Rue for his female impersonator friend Daniel Carroll.

Castle House had been constructed of ships beams in the Regency period. The whole place reeked of mystery and intrigue. It was indeed a house with a past. Smuggling associations seemed likely with the discovery in the cellar of a passage leading down to the sea, which had been partially blocked up long before the latest occupants settled in.

It so happened that shortly before this domestic upheaval, a social event of prophetic proportions took place. Lisa's mother had a friend by the name of Mrs McDonald who was employed by the Duke and Duchess of York as a dietary supervisor. Princess Elizabeth was just at the crawling stage when one day Mrs McDonald invited her friend to tea. Lisa begged to be allowed to accompany her mother to the Yorks' London residence at

Castle House,
Serene Place,
Broadstairs, Kent.

An experimental shot taken by Jimmy watched by Lisa in the first-floor living room of Castle House.

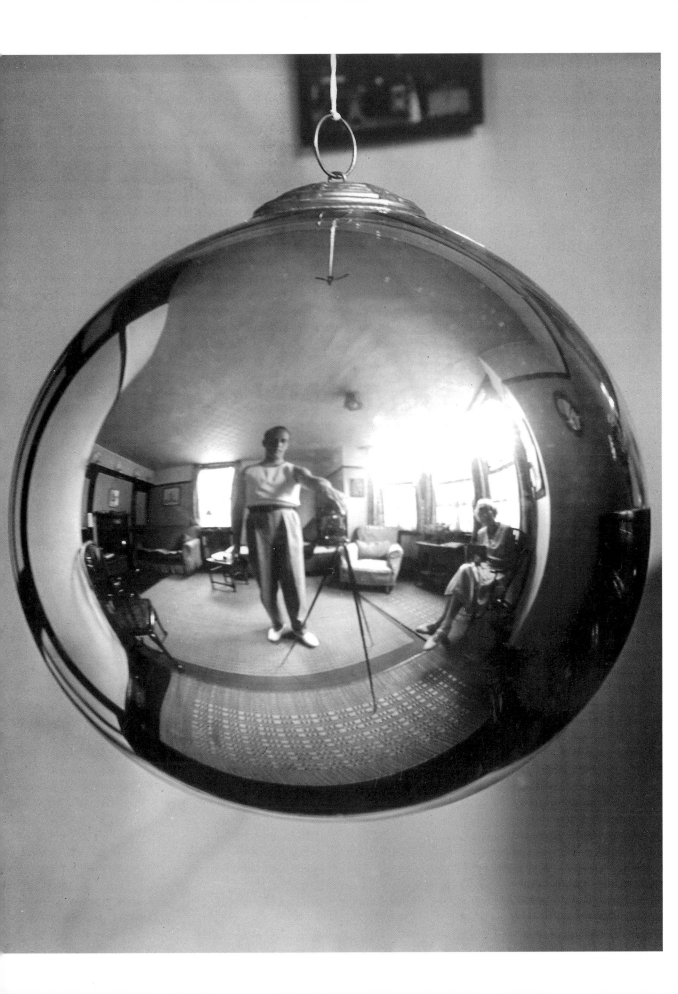

145 Piccadilly (later bombed and completely destroyed during the Second World War). The request was agreed to.

Mrs McDonald enquired of Clara Knight, the baby princess's nurse, known affectionately to the duke and duchess as Alah, whether her visitors might be permitted a glimpse of her young charge in the nursery. Lisa would recall 'a pretty doll-like face framed by soft silky curls' as the princess laboriously lifted herself up from a crawling position by way of a chair leg then flopped down again with an exasperated sigh.

Jimmy, to his credit, had exchanged kitchen gadgetry for the financial world by becoming a bank clerk. His knowledge of foreign languages and a certain adroitness with figures triggered the move. A slight increase in stipend provided the wherewithal for an occasional extra roll of film, but more importantly helped to defray the additional expenditure related to his younger daughter's illness.

For some time Dinah's wellbeing remained delicate, but when she was fully recovered the four of them utilised every corner of the quirky, narrow three levels that made up their seaside home at Castle House. It was ideal for experimental set-piece photography. Trial-and-error shots were the order of the day. Broadstairs, particularly in the summer, lent itself admirably to location work, prompting the family to seize any opportunity to picnic by the sea with their camera.

'No use hiding in a pool of water to prevent our getting wet'

The girls were enthusiastic supporters of their parents' hobby, although Jill's interest waned more easily than the younger sister's. Jill loathed being photographed outdoors, necessitating indoor work if her presence in front of the camera was required. This gave her parents impetus to think creatively to use whatever light was available, thus widening their photographic knowledge. Dinah, on the other hand, lapped it up and posed endlessly. Her natural ability and ease in front of the camera made her the most willing unpaid model an aspiring photographer ever had.

'The Sisters' at Castle House winning their parents first prize in a national newspaper amateur snap competition.

Together the four of them set about converting the eerie cellar into a darkroom. It wasn't such a small space either, more a good-sized room with a low ceiling beam running from one side to the other. In these murky confines the family installed a newly acquired second-hand enlarger so that Lisa and Jimmy could continue to perfect the technique of developing their own negatives and making a print from the result.

Returning home from school one day the girls noticed a newspaper cutting of themselves pinned to a board outside the chemist. The photograph entitled 'The Sisters' had been submitted in an amateur snap competition in a large circulation daily newspaper and had won first prize. They were all thrilled at this unexpected win, believing that other similar contests might crop up – which in the fullness of time they did.

During the years warmer months, mother and daughters were frequently spotted down in the bay with their props such as a brightly coloured beach ball and shrimp net, the ever-willing Dinah clad in her bathing suit. Lisa's younger daughter posed endlessly on or around the pier, along the sands, in a dingy, or rock pool. Sometimes a friend or two were added to a scene, or Sir Richard Roan, the family's blue roan cocker spaniel.

Castle House had no garden nor any space for one. A lengthy, paved, outdoor passage ran along the left-hand side of the dwelling and was known as 'the yard'. Here, if the weather allowed, the family could relax in deck chairs and enjoy a meal on their knees. When originally constructed, this venerable property had no bathroom. One was later added as a first-floor extension that cantilevered out over the yard at its furthest point. It was in this room that Lisa was relaxing in her bath one day while Jimmy acted the fool by dancing around with a towel wrapped about him. Suddenly the floor gave way, lowering Lisa unceremoniously in her tub, plus Jimmy, to the paving stones beneath. Remarkably neither of them were hurt to any great extent. While attempting to cover themselves with only one towel, the pair tried to attract Jill's attention by throwing pebbles up to her bedroom window, with the hope that she might let them into the house. This bathroom would ultimately play a pivotal role in the photographic lives of the Ginsburg quartet.

This 1931 photograph of Dinah in the family's Broadstairs bathroom unexpectedly set Lisa and Jimmy on the path to becoming professional photographers.

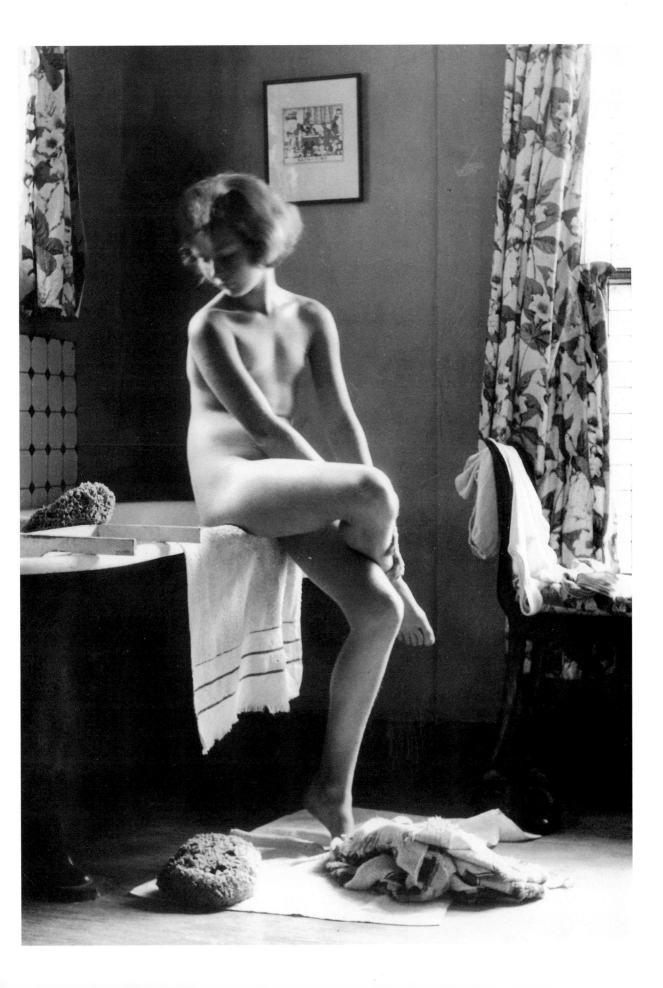

While Jill showed no great willingness to be captured by the lens of her parents' camera, Dinah was photographed looking at tempting displays in the baker's window, admiring scented fragrances in gift shops and receiving letters at the front door from the postman. Lisa and Jimmy would put their heads together of an evening to dream up such prospective photo opportunities. The resulting images, in the event they were good enough, they thought, could perhaps be sold for commercial purposes. They had a rubber stamp made, almost tongue-in-cheek, which when pressed to the back of some of their better print samples stated "Lisa," Castle House, Broadstairs, Tel 752.

The turning point in their lives came one beautiful sunny day as Dinah sat drying herself on the edge of the aforementioned bath. The bath was positioned alongside a smallish window with a bigger one at the end of the room. The light from both angles gave the 11-year-old's body the incandescent look of alabaster. Noting the effect, Lisa set her camera up before it was lost. Just as she was about to press the shutter the child looked down at a fly crawling up the side of the tub. The composition was improved dramatically but the resulting print showed the light to be a little overstrong on the head. With tentative ambition Lisa and Jimmy opted to retouch it on the negative. In hindsight it would have been better left as it was. 'Dawn', as they called it, was entered into a readers' competition in the *Evening Standard*, where it drew the attention of the paper's art editor. He immediately sent a telegram to Castle House requesting the photographer to come and see him when next in town.

Lisa duly presented herself at the Fleet Street office of the London daily, where the art editor, holding 'Dawn', wondered that, if she could do this, what else might she be capable of? He promptly sent her to the editor of an avidly-read women's page, who needed photographs depicting scenes with a homely appearance. Men, she maintained, could not give what was required; they just didn't have a woman's touch. So, how about it? Would Lisa feel confident enough to set about illustrating, among other things, cabbages that could accompany recipes dealing with the various ways in which that vegetable might be cooked and served? She would indeed. 'What's more,' came the editor's voice, 'I need a child cleaning its teeth

Dinah in a convex mirror outside Castle House.

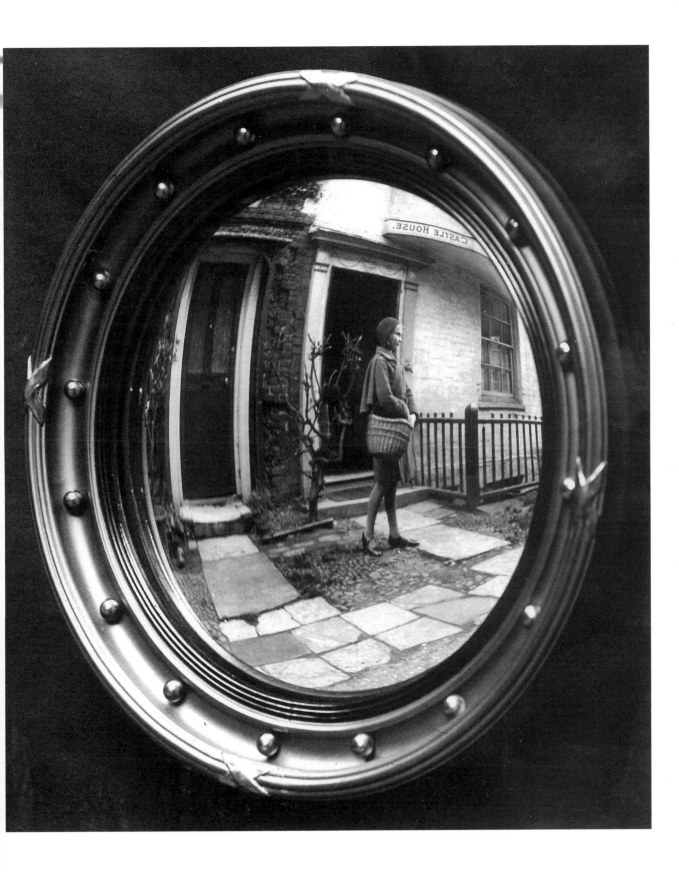

along with an accompanying text on dental hygiene and captions to go with it.'

Numerous enlargements of 'Dawn' were requested as well, along with copies of a little series of prints entitled *The Mirrored Day*, which showed aspects of Jill and Dinah's daily routine reflected in a framed convex mirror of classical design.

'Is this really too much?' thought Lisa as she travelled home by train that evening. 'Am I out of my depth? What would Jimmy think? Didn't that woman say she could only get from the likes of me what was required?'

The following day, at the greengrocers in Broadstairs High Street, the assistant entered into the spirit of things. Together she and Lisa weighed up the photographic pros and cons of the everyday cabbage. This would become a process repeated often. On one occasion when Jill was doing the buying, a lady behind the counter enquired whether the fruit and vegetables being purchased were for eating or decoration.

Recognition acted as a catalyst. With her entrepreneurial flair, Lisa's notion that speculative photography did indeed have a place in the scheme of things prompted her and Jimmy to embark on a marketing strategy of their own – after all, look at the advertising world, and all the articles and stories that needed illustrations. She took the train up to London whenever her husband's limited income could stand the extra travelling expense. In the city, Lisa would set about engineering introductions to editors of journals that featured household pages that might be illustrated with her speculative photographs. Having discovered there was a need for illustrations with themes – baby care, food preparation, seasons of the year and so on – Lisa would return home from these sorties with her imagination well and truly fired. With Jimmy, she then sat down and worked out a plan that would perhaps, if they could handle the hoped-for results, work in their favour.

Such was Lisa's ingenuity that she developed each idea to its fullest, pre-empting what she felt prospective art editors might require. Intuition played a large part in those early days when trying to assess what would be commercially needed. Lisa and Jimmy aimed to be one step, if not two, ahead in what was without doubt a most competitive field.

Certain days of the week were set aside as selling days. With her bag full of print samples Lisa would leave for London full of hope and trepidation. As time went by, sales began to stack up, and she would return triumphantly to Castle House announcing what she'd been able to sell and at what price.

Ideas constantly came to mind. Dinah, for example, would be photographed moving the hands of a clock when wintertime changed to summertime. As the girls set off for school in their uniforms their mother followed them to the station, camera in hand, to record their departure. Surely someone, somewhere would be looking for such a shot.

Despite the success that began coming their way, the family's domestic purse allowed little latitude for anything other than basic equipment. Many a consultation took place down in the cellar between Lisa and Jimmy and the two girls. The numerous issues that arose were very much a joint affair, each of them equally as astounded as the other when they got it right.

Lisa continued to sketch a proposed photograph on paper, taking a tri-angular shape as the basic design. Remarkably, the technical details of the camera were not always her strongest point. That aspect of photography was more her husband's forte. He thoroughly enjoyed determining the finer points of exposure and dealing with the more head-scratching issues as they cropped up. His wife's strengths lay in her artistic ability in com-position and an outstanding flair for setting the scene and assessing light and shadow. Their respective skills contributed to a well-oiled team har-mony that would eventually carry them through the years of professional partnership that lay ahead.

One thing remained constant: the half-hour afternoon naps that Lisa had developed the habit of taking would not be given up. In years to come she would make it known that only for Her Majesty The Queen would she forgo this time-old ritual.

Every room in this home became a potential backdrop for photography offset by the very clothes the family wore. Even household kitchen utensils developed a life of their own as props depending on what theme was before the camera at any given time. Whilst resting one day after

lunch as her daughters played downstairs with a friend, Lisa could hardly contain her mirth when the young visitor declared that she felt positively ill when seeing illustrated in the local paper a few days later the food they had eaten together at Castle House.

Local retailers became quite accustomed to their premises being used for location work. Nearly six decades after it was taken, Dinah was sent a photograph of herself as an 11-year-old being served by a young woman (the sender and still a local resident) at Bowkett's Bakery in Broadstairs High Street.

On the underside of their prints, Lisa stamped her details.

Within the fullness of time Lisa managed to carve a niche for herself in the ever-changing magazine and newspaper world. Tenacity paid off. To London editors she became 'the photographer from Broadstairs', a heady title she secretly enjoyed, albeit with nervous reservations. Such an elevated status was beginning to carry weight, particularly as photographs bearing her name had started to satisfy demand. Her feminine instinct for domestic-orientated media illustrations was fast outstripping the work of her more experienced male contemporaries.

Meanwhile a young man selling eggs walked down Serene Place and knocked at the door of Castle House. Jill and Dinah engaged him in idle chit-chat, and discovered that photography was his one and only hobby. By the time Frank Price left, with his egg basket empty, he had been employed two days a week to help out in the basement darkroom.

The unforeseeable was beginning to take place. For the Ginsburgs a photographic career had never been seriously contemplated, but fate was pointing them in that direction. With their commercial reputation as photographic press illustrators beginning to escalate, Jimmy, who had never been entirely happy in banking, found himself at a crossroads. He might be faced with giving it up. Was such a prospect wise? Who in their right mind walks away from the stability of the banking world? Friends and relations united to try and make the family see sense, prophesying financial ruin and at best a poverty stricken old age. Notwithstanding

such forebodings, caution was thrown to the wind. The four main players, Lisa, Jimmy and their two girls, collectively weighed up the pros and cons and decided to give it a serious go. 'No use hiding in a pool of water to prevent our getting wet' was a maxim Lisa always stood by. If, after six weeks, satisfactory progress could be made, they would set themselves up as professional photographers, prepared to make it or break it. The die was cast, so Jimmy handed in his notice at the bank.

Success brought its own form of disruption. Castle House was far from suitable for full-time photography. The first-floor living room with its spacious bay window had become the 'studio'. But when a wedding party arrived to be photographed, but could not be fully accommodated, it became obvious the Broadstairs days were numbered. Added to this Jill, at 16, wished to pursue a career in dressmaking, while 13-year-old Dinah had commenced her theatrical training. Both needed to be closer to London.

Leaving their home by the sea for a conventional suburb was unthinkable. The family, who were considered by acquaintances to be 'original', had already been drawn to Ebenezer Howard's new town of Letchworth in the leafy spaciousness of Hertfordshire. Reports of the early, arty, calico-clad, sandal-wearing residents there somehow heightened the photographers' interest. Both were drawn to the town's cottagey architecture. But, when they discovered the more recently developed Welwyn Garden City, a little to the south of Letchworth and only 20 miles north of London, Lisa decided to investigate further.

Welwyn Garden City was Howard's follow up to his first success at Letchworth. There were differences though. A more uniform style of architecture was adopted for Welwyn and put into practice at the hand of architect and town planner Louis de Soissons, who introduced its now celebrated red-brick neo-Georgian appearance. This design concept was adopted for residential housing, retail and commercial construction offset in each case by windows and doors in plain white only. Building was undertaken amid existing trees and hedgerows, the seeds of which had been planted eons before and still exist.

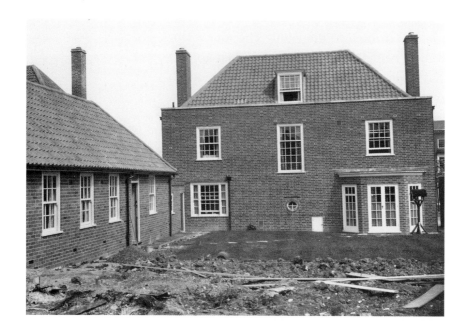

A view from the
rear of 14 Parkway,
Welwyn Garden
City, Hertfordshire,
when the house
was first completed
in 1934. The new
studio is on the left.

In 1934 the town was just 14 years old and still very much in its formative years. Today, town planners come from all over the world to study what has been achieved there. With its wide tree-lined streets, where each home has a garden and where shops, offices and factories are all, in the main, within walking distance, as originally envisaged, the town has become an inspiration for similar developments in numerous countries.

Parkway, with its dual carriageways separated by lawns, rose beds and avenues of lime trees, cuts through the town centre, separating the compact residential areas from the handsomely proportioned retail district and that of the industrial and commercial sectors.

Lisa visited a recently finished, unoccupied house at 14 Parkway, and was instantly enchanted with what she saw. A local building firm known as The Viner Brothers, renowned for putting more quality into its work than what it got back financially (hence the company's eventual demise), was responsible for its construction. They had lately finished the property next door, which Mr G.J.M. Viner had moved into. He duly placed a nondescript sign outside No. 14 that simply said 'Show Home'.

The dwelling was ideal, close to the town centre and railway station with its fast trains to King's Cross. The 150ft-long garden to the rear provided ample room for a purpose-built studio. An instant decision to purchase was immediately rebuffed by the builder. He pointed out that it was in fact a home acting as a blueprint from which others could be built. 'But we are photographers,' protested his interested party, 'and this centre position so close to amenities would be ideal for us.'

Photographers! The magic words had been uttered. In its infancy Welwyn Garden City encouraged a whole host of different businesses, and a photographic concern had not yet established itself in the town.

The deal was duly sealed, and local builders managed by a Tom Kell were engaged straight away to construct in the garden a new studio echoing the same neo-Georgian style of the house. It was only half finished when, in March 1934, Lisa, Jimmy and their two teenage daughters made the transition from the south-east coast of Kent to their new life in the Home Counties. When complete, the studio floor space, with small raised stage across the width of one end, two darkrooms and modern equipment beyond their dreams, was well worth waiting for.

The uniqueness of the garden setting behind the main house – it had what Dinah called an 'honest-looking face' – would prove to be a popular drawcard for clients in the years to come. Prospective sitters rather enjoyed having the choice between being photographed in the studio or outdoors – a novel option for the time. In due course the garden would offer any number of different settings, irrespective of season. There was an ornamental pond complete with water lilies, quaint little pathways that wound between a carefully chosen selection of trees and shrubs, a rustic summerhouse, picket fences and surprising corners of goblin-like proportions for the very young.

As much as the garden was ingeniously thought out and planned, so too was the interior of the house. Here, furnishings and fabrics were selected for their photogenic value. A homely atmosphere prevailed, leaning toward what might be described as eclectic in appearance.

As an illustrative enterprise specialising in images for the press and advertising fraternities, the business got off to a good start and expanded

rapidly. The first recorded mention of Studio Lisa's association with the garden city appeared in the *Welwyn Times* on 7 June 1934 when a photograph of a local Thalians production attributed to 'Lisa' was published.

Portraiture also was starting to bring them considerable local recognition, as was their recording of the escalating growth of Welwyn Garden City. Jimmy especially enjoyed watching the town's expansion, turning his casual inventory system into something of a hobby. Photographic records documented by him during Welwyn's formative years now comprise a collection of unique proportions much valued by global students of the garden city system.

A new stamp was made. Elevation to 'Studio Lisa' had not quite taken place during the earliest garden city days.

Lisa was becoming increasingly preoccupied with young mothers wheeling prams. Babies were often required for product illustrations. Turning to the happy, beaming parent she would ask for a name and address. Local mothers duly took to walking up and down Parkway outside the studio pushing their perambulators in the hope of being stopped. To Lisa, babies were natural models, and never too young at that. It was her view that they spoke with their facial contortions. As if to stress that point she embarked on a pictorial account of infant expressions at the moment of birth. The youngest was only two minutes old; some were ten minutes, others an hour or so. Such was her interest that over the years she kept track of some of her first faces, comparing later expressions to those noted at birth.

When photographing babies as they grew older and therefore more animated, Lisa perfected the contrived expression by becoming somewhat inventive. She would for instance sprinkle chopped parsley on bath water, which induced an expression of surprise and delight on the face of the youngster splashing around while looking into the camera lens. Conversely, a piece of sticky tape stuck to a baby's finger might result in a look of intrigue.

If a nervous child arrived at the studio only to find the photographic paraphernalia unnerving, Lisa would appear in a zany hat to divert attention

and help the young sitter to relax. Coaxing the child still further, she would hand it a toy telephone and say, 'This one is yours, and here's mine. You ring me and I'll answer.' Jimmy would be ready behind the camera waiting to record the result. When a group of children were involved, Lisa would ask, 'Am I too old to join in your party?' Sometimes she might proffer a yellow hanky saying, 'Do hold this red one for me. It's my favourite colour.' Attention would be gained immediately as the child contemplated correcting an obvious error, all the while losing any self-consciousness that might otherwise have ruined the portrait about to be taken.

When it came to commercial illustrative work requiring a young model, where possible it was always Lisa's preference to engage a local child, with no preconceived ideas of behavioural patterns in front of a camera. Spontaneity and a willing adaptability were often better than the training given to the professional child model. Besides, for youngsters reporting for work at the studio in the garden there was always the prospect of playing with 'the lady photographer's toys'. These incidental props – housed in a large cupboard inside the studio – were worth their weight in gold as attention-getters for nervous children. Realising that Studio Lisa's commercial images were good shop windows for their wares, well-known toy manufacturers regularly sent along new lines for possible use. Some years later, it startled Lisa and Jimmy somewhat to realise that Jill and Dinah's young children surmised that their grandparents might be keeping such a huge toy collection for their own enjoyment! A grandson duly put such a prospect to Lisa: 'When we aren't here, do you and Popski get the toys out and play with them yourselves? Well, do you?'

Whatever the photographic work on hand, the huge Welwyn Stores complex directly opposite the studio gave Lisa the freedom to choose from their stock whenever incidentals for her illustrative work were needed. When finished with, these items would be returned to the store and put back into stock. Illustrating food in its various forms became part and parcel of studio life. Working one or two seasons ahead often meant photographing turkey in high summer and vast quantities of ice cream in winter. Picnics during the coldest months weren't unknown. Jill and

Dinah very quickly stopped asking 'What's for dinner?' in favour of 'What have you been photographing today?'

A certain artistic sleight of hand was often employed, as wastage of food in a photographic studio can be considerable. Mouthwatering-looking pies complete with delicate pastry tops probably contained sand or crumpled paper. A tempting glass of wine may well have been vinegar, cold tea or coffee. Seeing their parents' cunning, the girls threatened to expose them on more than one occasion. There was one instance when a firm of advertisers requested illustrations depicting various ways with ice cream. Blocks of it were delivered daily to the studio but immediately turned to sludge beneath the heat of studio photo lamps. A process of elimination however revealed that a certain Dutch cheese, when trimmed and suitably decorated, conveyed the impression of ice cream. Lisa became something of a dab hand at this line of artistic subterfuge, using the family kitchen adjacent to the studio for initial food preparation in whatever form it was required. When ready, the results would be arranged in front of the camera when action was called for.

When professional models arrived at the studio they invariably had to be scrubbed clean of layers of make-up and nail polish. This was often objected to, especially if it all had to be put back on prior to moving off to the next assignment.

As the workload increased and photographs attributed to 'Studio Lisa' became associated with Welwyn Garden City's only photographic enterprise, more assistance became necessary. One of the first to be employed was a young local girl in her late teens named Pat. Many years later she would recall the obvious display of warmth and affection shared between Jimmy and Lisa as the latter sat on the arm of her husband's chair whilst they discussed Pat's employment.

A live-in Austrian maid by the name of Ami had already been installed to relieve the pressure of household chores. A former concert singer, Ami had suffered some throat operation that had cut her vocal chords. Whilst a croaky voice hampered her already limited English, it didn't prevent a bond of friendship springing up between her and Pat. Pat's blonde attractive looks soon lead her into part-time photographic modelling,

The studio's frequently referred to and now sought-after record of Welwyn Garden City's development was constantly updated, as this early contact sheet of diverse illustrations shows.

HERT. 301.

L. HERT. 10.

H. HERT. 403.

D.1482.

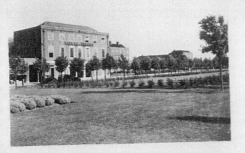

0.917.

L. HERT. 116.

STUDIO LISA

HERT. 815.

HE RT. 337.

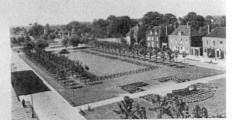

L. HERT. 117.

HERT. 340.

PHONE: WELWYN GARDEN 850

HERT. 336

thereby at times diverting her attention from the secretarial duties for which she had been recruited.

Her arrival at the studio almost coincided with that of Andree, another equally pretty teenager. Andree was officially an apprentice and paid for her own training, which included preparing lights and getting to grips with related technical aspects. Frank Price (the egg man from Broadstairs) assisted her with darkroom training.

Taking on Pat was a timely move for her employers in more ways than one. Up until then, so-called 'office' procedure had been something of a hazardous operation. Lisa and Jimmy made no bones about the fact that neither of them had been blessed with anything resembling a business mind. The process of recording day-to-day income and expenditure in a series of notebooks and allowing invoices to simply pile up had to change. Ben, a family friend who was an accountant by day, was called in to take charge of the bookkeeping, teaching Pat to take over when the books resembled some sense of order. Ben, however, could only make himself available of an evening to work on accounts, requiring Pat to go home after a day's work for her supper and then return to the studio afterwards. Her mother complained that she talked figures in her sleep after a night of serious concentration.

A colour photograph of Ben and Pat was taken by Lisa in the window alcove of the dining room, which also doubled as the office. The pair are seen looking intensely at the so-called 'books', in which income and expenditure would in future be recorded. This particular image had significance for two reasons. Firstly, as Pat recalled, the staff were there to work, but Lisa, always ready to make use of any moment or idea as subject material, decided to record this shot in case it might have found some commercial value. Secondly, it was the beginning of the studio's use of colour, then processed in America. The cost, slowness, and the fact that colour then was all a bit new, hampered its immediate adoption as an alternative to the more traditional black-and-white photography the Sheridans were accustomed to.

Pat and Andree had been at school together and, although they now worked for the same firm, a division of labour coupled with the irregular

Images of cookery subjects, the preparation of food and its presentation were frequently asked for.

PHONE: WELWYN GARDEN 850

STUDIO LISA

studio hours meant they hardly saw each other. Exceptions did occur on the occasions when they were both required to act as models for studio or location work. Having been photographed for a Kodak advertisement, Pat was somewhat astonished one day when walking past the Kodak shop in London to meet head on a life-size cut-out of herself promoting the company's products.

Lisa's tremendous drive to diversify was always apparent. Utilising her child psychology skills and adopting the nom de plume 'Mrs Everth' (her maiden name) she became a freelance writer for periodicals such as *The Ideal Home*, where she wrote on subjects ranging from 'Colour in the nursery', 'When children live in the open', 'The family on holiday', 'The leisure hours of older children' and similar.

Here she was able to combine her talents as illustrator and wordsmith. In Lisa's opinion nothing was impossible. Such infectiousness propelled Pat into a marketing role, using skills she hadn't realised she had. Every Tuesday she was dispatched with a satchel full of speculative photographs, bound for London and the art editors of Fleet Street who invariably found in these samples what they were seeking.

Two years after getting established in Welwyn Garden City, the work of Studio Lisa had spread considerably. Primarily the emphasis tended to focus on family life and activities allied to it. Everything that was pictorially recorded reflected a fresher, uncomplicated, more natural approach, with outdoor photography much in evidence. This drew to the public's attention a hitherto little known aspect of photography. Such undoubted flair had begun to bring the studio a considerable element of acclaim which lead its owners in two life changing directions.

Before leaving the Kentish Coast, Dinah had begun studying at The Italia Conti stage school in London. By the age of 15 her acting talents had started propelling her toward what would become international recognition. However the young actress was in a quandary. She felt the name Ginsburg might not resonate with the world of entertainment, and she began to consider a change of surname. Dinah's parents, as it happened, felt that a more anglicised name would do them more good than harm, so when their daughter stuck a pin in the phone book and

Pat referred to this as 'The Three Graces' – a commercial image taken in the studio. That's her on the left, with Dinah and Andree to the right.

struck 'Sheridan', the name appealed to them, prompting a joint decision to adopt it. Jill, though, wasn't so sure, feeling that the name she was born with was perfectly acceptable. There was no specific pressure to change, but of her own volition, upon further consideration, she opted to take on her family's new name, which was listed for the first time in the Welwyn Garden City telephone directory of 1936.

From Kings to Cabbages

What happened next could never have been anticipated and it came quite simply with a knock on the door. The visitor was a local and noted writer of books about dogs. He was preparing a new volume on royal canine friends and for the first time wanted to decorate his text with photographs. What he had seen and heard of Studio Lisa's ability with children and indeed animals was enough to convince him that the Sheridans fitted his requirements. Would Lisa and Jimmy, he enquired, care to accompany him to 145 Piccadilly, the London home of the Duke and Duchess of York and their daughters Princess Elizabeth, aged 10, and Princess Margaret Rose, aged 6? The proposed book would feature photographs of King George V's second son, his wife, two daughters and their family pets. To Lisa and Jimmy it was the opportunity of a lifetime. They couldn't believe their luck and spoke of little else.

Their high spirits though were unexpectedly dampened when, having completed their photographic task and submitted their proofs, their new author friend promptly betrayed them by selling the copyright of the pictures to the national press. Such action totally breached copyright laws pertaining to the supply of royal images. The Sheridans were justifiably mortified. They wrote immediately to the Duke and Duchess of York expressing their horror at what had happened, with an explanation and apologies. To their great delight they found themselves being invited by the royal couple to take a totally new set of photographs – not exactly what they might have expected from such an embarrassing situation.

From the outset, Studio Lisa became known as innovative photographers of children and animals, as illustrated on this contact sheet.

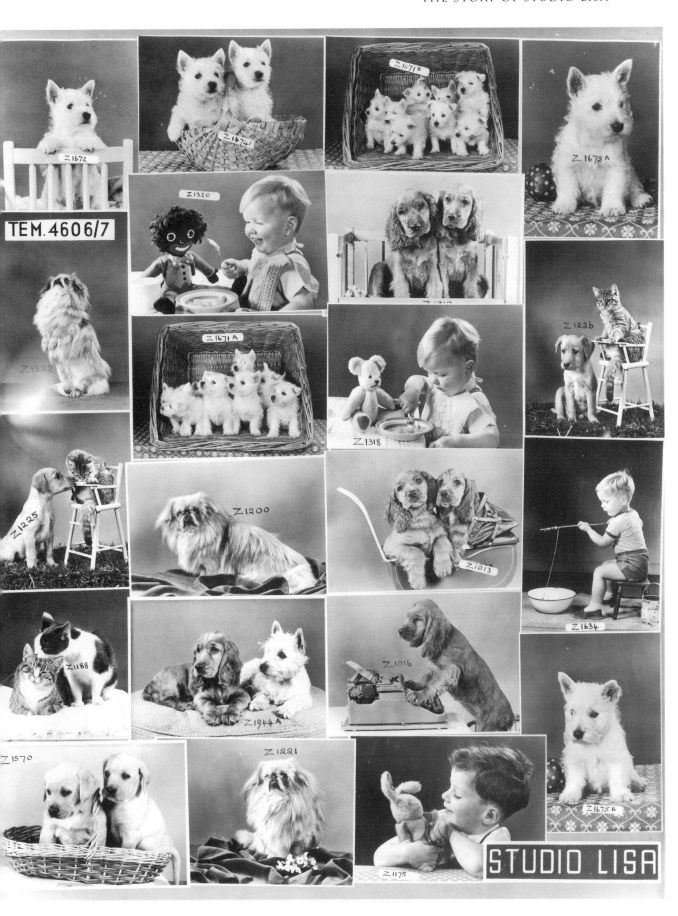

On a beautiful June day in 1936 they set out for Royal Lodge, the Yorks' Berkshire country home in Windsor Great Park. The morning had begun with threatening clouds, but the skies cleared and the sun shone as they neared Windsor. Thinking that they had allowed enough time for their journey, nothing could have prepared them for the difficulty in locating Royal Lodge. Huge oaks obscured the view, whilst repeated snatches of the pink building with its flat roof and white battlements came and went, as the road seemed to wind round and round leading seemingly nowhere. An enquiry sent them back to the Copper Horse, which in their ignorance they mistook for a pub that didn't exist. A further enquiry succeeded, but by now it was too late to arrive on schedule – a situation the photographers felt was nothing short of unforgivable.

The first thing the couple noted having actually got to Royal Lodge was a small corgi busily scratching the front door's paintwork. As Lisa was about to ring the bell the front door swung open as if by itself. A sharp whistle rent the air, sending the little dog charging inside. Through the doorway two rocking horses could be seen in the hall, along with a pair of enormous vases that sat on the floor, holding voluminous sprays of bright yellow forsythia. Suddenly Lisa and Jimmy found themselves face to face with the Duke of York. With a broad grin he laughed away their profuse apologies for their late arrival. Nearby, a canary burst into song and momentarily cast Lisa's mind back to another royal household, the palace of the Tsar in St Petersburg that she had visited as a child, where birdsong could be heard all year round. In due course two little girls in yellow pullovers and tartan skirts came running downstairs to be introduced by the Duke of York as Lilibet and Margaret Rose. The older child was noticeably more reserved than her effervescent younger sister.

As they all stood on the terrace the Duchess of York, dressed in a simple black frock adorned with a spray of heavily scented jasmine appeared through an open French door. Her relaxed, smiling charm ensured that an air of friendly informality was immediately established. The duchess asked numerous questions about the Sheridans' studio life in Welwyn Garden City. She also offered many constructive ideas of her own about the day's photography ahead of them.

'So you thought the Copper Horse was a pub, did you?' proffered the duke good-humouredly. The fact that it turned out to be an equestrian statue of King George III dominating the Long Walk was never to be forgotten by the two new royal photographers.

The garden at Royal Lodge was ideal for photography. It included the Little Welsh House with a thatch roof given to Princess Elizabeth by the people of Wales. The rooms and their contents had been scaled down to suit the requirements of two little girls aged 10 and 6.

As the Sheridans unpacked their equipment Princess Margaret turned somersaults on the lawn. Watching Lisa unfold a camera she explained that her sister had one similar and it also folded out in the front but when she used it the results weren't always successful. Suddenly dogs appeared, labradors and corgis along with a cheeky Tibetan lion dog known as Choo-Choo, which the duchess immediately scooped up in her arms. Choo-Choo, referred to by the duke as 'this most unsavoury member of the family', then began to munch his way through the spray of flowers protruding from his mistress's buttonhole. Quietly, Princess Elizabeth picked another small posy and pinned it to her mother's lapel. The duke and the princesses, all three of them oblivious to the camera, proceeded to busy themselves by calming the dogs who tumbled in all directions. On hands and knees the Duke of York induced them to sit quietly whilst Lisa, heart in mouth, posed the family with their pets ready for the first official Studio Lisa royal photograph ever to be taken.

At their mother's suggestion the young princesses later changed into simple cotton frocks. It had been decided that pictures should be taken outside the Little Welsh House, an idea that subsequently met with approval worldwide – the resulting images became international favourites and were reprinted in newspapers and magazines in countless countries.

Spontaneity is evident in this set of photographs. The young family's unity is displayed without any affectation – take, for example, the image of the Duchess of York leaning out of the window to watch her daughters and their father at play with the dogs, one that would go on to become one of Studio Lisa's most durable success stories. Another photograph taken only minutes later of the Little Welsh House shows both princesses

leaning from the windows either side of the front door. The duke was kneeling down out of sight in the tiny kitchen, raising and lowering his younger daughter as Lisa requested. She then nodded to Jimmy to record the moment. Much hilarity preceded the actual click of the camera in the taking of that scene. The arrival of two small ponies, led by a groom, signalled the end of an exciting assignment, and photographs of the princesses in riding attire on their ponies brought proceedings finally to a close. It had been a long day, and one not without an element of nervous tension for the Sheridans.

The next day proved to be one of the most exciting twenty-four-hour periods in the studio's history. Hour by hour as the negatives were developed each was scanned for imperfections. As luck would have it there were none, and Lisa and Jimmy hugged each other in delight. Only then did Jimmy realise that he had left a valuable lens on the lawn at Royal Lodge. His wife phoned immediately, instructing the man who answered at the other end to pack it with great care.

'Certainly,' came the reply.

Lisa then went on to enquire as to whether yesterday's photographs should be posted directly to Royal Lodge or held back and taken to 145 Piccadilly, where she and her husband were undertaking further photography the following week.

The voice on the other end tentatively asked after the quality and whether they had turned out satisfactorily, requesting that they be sent on by post. Next week would be too long to wait. Only then did Lisa realise that she had been speaking to the Duke of York himself. He laughed at her confusion, dismissed her embarrassment, and promised to return the lens perfectly packed.

At 145 Piccadilly, as had been the case at Royal Lodge, it was the natural easiness of the repartee between the royal foursome that captivated Lisa and Jimmy most. There was, though, one particular incident that stood out during that second photographic session. The garden at the Yorks' London residence had little privacy as it joined nearby Hamilton Gardens which was in turn enjoyed by other neighbours who lived in the large exclusive dwellings close by. Over the railing was Hyde Park, from where

A studio contact sheet depicting Princess Elizabeth and Princess Margaret in the mid 1940s.

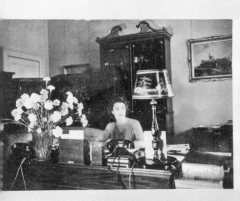

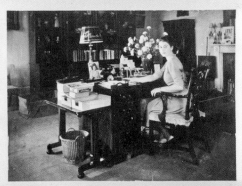
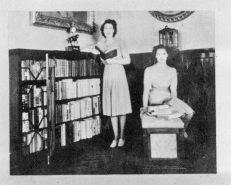
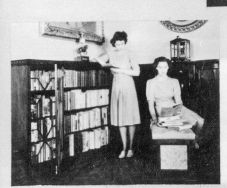

STUDIO LISA

the public, in those days, could watch the two royal princesses at play in their own back garden. While photography was under way Dookie, one of the royal corgis, got into a scrap with another dog on the other side of the railings. Both barked furiously, much to the delight of the passers-by. Later, full of remorse, Dookie returned to his family in his own territory. Princess Elizabeth lifted him into her arms, and gently lowered herself onto a garden seat, both dog and little girl closing their eyes as sweet nothings were whispered. Lisa stole up and quickly recorded the incident, which especially delighted the duchess, who treasured the result.

No one on that summer day in 1936 could have foreseen the dramatic changes in royal fortunes destined so soon to alter the lives of the Duke and Duchess of York and their daughters. When next they stood before the cameras of Studio Lisa it would be as Their Majesties King George VI and Queen Elizabeth, while Princess Elizabeth would be heir presumptive following the abdication of the uncrowned King Edward VIII.

As with the developing of the Royal Lodge pictures, those taken at 145 Piccadilly received special attention. Only one or two were done at a time, as in their nervous eagerness the Sheridans and their darkroom staff made necessary and, as they admitted themselves, often unnecessary adjustments to obtain a quality of development no less than perfect.

On the day-to-day running of the studio it was usually Frank Price who took charge of the darkroom work. Contact prints were immediately taken in to Lisa who sorted them into rejects which would be destroyed and those to be kept numbered for reference and filing. She would outline in pencil how she would like these printed, taking in all or part of each frame.

Following the euphoria associated with the first lot of royal photographs, the Sheridans returned to the familiar run-of-the-mill studio work. It was during one of these less frantic periods when loose ends were being caught up on, it came as something of a jolt to realise that incoming financial rewards amounted to an unexpected loss. Spending would have to be curtailed. Above-average equipment for a suburban studio, staff expenses coupled with unlimited ambition had collectively started to tug at the purse strings.

Dealing with the more mundane aspects of studio work found Jill remarking one day, as yet another cabbage lay before the camera, 'From Kings back to cabbages now is it?'

Tradesmen continued to enter into the swing of photographic requirements. Greengrocers learnt to view each carrot from an artistic angle just as the local butcher would weigh up a leg of lamb for its pictorial value.

Animals also began to play a significant part in the studio's day-to-day activities. Throughout her professional life Lisa maintained that, when not photographing babies and young children, she was never happier than when spending a day occupied with animals for calendars, postcards and advertising requirements.

By the end of 1936 the photographs taken at Royal Lodge and 145 Piccadilly had gone to illustrate a new book entitled *Our Princesses and their Dogs* published by John Murray.

As the national and international press swooped in on the abdication crisis in December of that eventful year, photographs of the Yorks by Studio Lisa were used all over the world, underlining the united family theme the new King George VI, Queen Elizabeth and their two young daughters would bring to a throne that Edward VIII had chosen to abandon.

In May 1937 the Coronation took place in Westminster Abbey. Scanning the pictures taken on that remarkable day, it seemed to Lisa and Jimmy that the stern expression etched on the solemn countenance of the man who was now their monarch contrasted sharply with the smiling features of the one they had come to know as the Duke of York.

Meanwhile, at 14 Parkway, family life had begun to establish a pattern of its own. Jill was now earnestly studying dress design, which would eventually lead to her creating some of the garments that her younger sister would wear on the screen.

Dinah was forging ahead by establishing a name for herself on the stage and in the film industry. Her parents, well aware of this younger daughter's visual attractiveness, had many an opportunity to employ her in a modelling role. Pictures taken of her for advertising purposes, particularly the Welwyn Garden City-based Shredded Wheat breakfast

cereal, were to become well known to virtually every household in Great Britain. At the age of 17 she won the premier figure competition award in the *Daily Mail* beauty contest. Celebrating this, the national press ran an image of Dinah in a bathing suit about to throw a beach ball. This resulted not only in widespread exposure for herself but likewise for her parents, who had taken the photograph.

Lisa followed up all promotional opportunities with the zest of a true entrepreneur. Many of these came by way of her husband when he was enjoying a drink at The Cherry Tree, not five minutes' walk from the studio. A friend who invariably joined him was the manager of the now long-gone Welwyn Film Studios. New faces were discussed, remembered, and later tracked down by Lisa. Some of Studio Lisa's most famous portraits of the day include Errol Flynn, Flora Robson, Jack Dempsey, Amy Johnson and her husband Jim Mollison, H.G. Wells and A.A. Milne.

At one point Lisa wrote to George Bernard Shaw, who lived in the village of Ayot St Lawrence, in the Hertfordshire countryside near Welwyn Garden City. Having expressed her admiration for him and an appreciation of his work she asked for permission to photograph him. His response written on a postcard said 'No!' Realising this was the only form of correspondence he understood, she wrote again, on a postcard of her own saying, 'You might as well give in now, because I am determined to photograph you before you die.'

He replied, ' Thursday 3.30 p.m.'

During the resulting photo session the subject of *Peter Pan* was raised, to which Shaw displayed much antipathy. 'No one should want to grow up', was his view. It was, he believed, a bad play for children, bettered by his own *Androcles and the Lion*, which should at all costs replace *Peter Pan* as the annual children's entertainment. Asked when he had most recently seen *Peter Pan*, he replied, 'Last Christmas in Bournemouth.'

'Ah,' said Lisa, 'you would have watched my daughter Dinah playing Wendy.'

Dinah, outside in the car, was quickly asked in. A mutual bond of admiration was immediately formed while the pair were being photographed.

This image of Dinah celebrating her *Daily Mail* beauty contest win was given widespread print media coverage and used to advertise a promotional booklet for Studio Lisa.

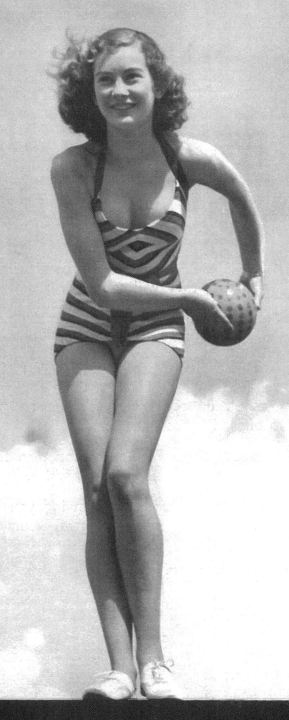

STUDIO LISA

PHOTOGRAPHS FOR
COMMERCE & INDUSTRY

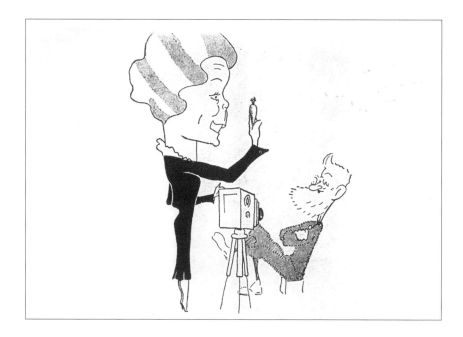

A caricature sketch of Lisa Sheridan with George Bernard Shaw, whom she was determined to photograph despite his misgivings.

Other photographic sittings with George Bernard Shaw would follow. One of Lisa and Jimmy's most affectionate memories of these was of Shaw, in his wide-belted Norfolk suit, standing at the gate directing their car as they backed out of the driveway of his home, Shaw's Corner. He loved to play policeman, halting proceedings with a raised hand before waving their car on. Each visit ended the same way, winter and summer alike.

'Their Majesties are ready for you now.'

As the third decade of the twentieth century drew to a close, war seemed a certainty. Working at the studio Pat recalled an element of panic as sandbags were stacked up outside the windows of 14 Parkway. So-called luxury professions were not allowed to employ those of call-up age, so the younger staff members had to go.

One day in 1940 a letter arrived from Buckingham Palace asking the Sheridans if they would travel to Windsor Castle to photograph King

George VI, Queen Elizabeth, Princess Elizabeth and Princess Margaret. There was huge excitement, prompting the overhaul of cameras, unused for months, so they could be put back into commission.

Having arrived at the Castle, the royal photographers found themselves redirected approximately three miles on to Royal Lodge.

It was the princesses whom they met first this time. They were in riding attire just as they had been at the end of the first photography session in 1936. After slipping away to change into skirts and pullovers, they returned, and Princess Elizabeth announced, with a twinkle in her eye, 'Their Majesties are ready for you now.'

There were warm greetings along with the same air of informality that had prevailed four years before. Lisa and Jimmy were struck again by how simple and natural life appeared to be at Royal Lodge; the Queen told them, 'This is our private life, this is home.'

Some years later, when discussing Royal Lodge, the Queen Mother (as she had become by then) explained to Lisa that she and the late King had chosen the furnishings for Royal Lodge themselves. They preferred a very indoor–outdoor style of décor, doors and windows open, with flower-adorned rooms to complement the bird-filled gardens. Not being a large home by royal standards, it was as far removed as possible from the generations of splendor more apparent in Buckingham Palace and Windsor Castle.

In the time since their last meeting Princess Margaret had lost much of her puppy fat, while Princess Elizabeth appeared taller and slimmer but otherwise unchanged. The Queen had become a little more assertive. Since the last photographs were taken a Coronation had taken place and a world war had begun. This no doubt helped to explain why the King appeared older and a little tired, somewhat restless, even. But collectively, the family's ability to put people at ease was still very much to the fore. The King joked that they had all grown appreciably since their last meeting. 'It's only the Little Welsh House that hasn't altered,' he said.

During the ensuing photographic session the princesses were pictured working in their garden and by the stables with their ponies. Lisa noted that Princess Elizabeth could perhaps be a trifle young for her years.

She possessed what the photographer believed to be a loving, emotional sincerity that showed nothing in the way of overt sophistication. Of the two sisters the older showed a more contemplative side with a slight tendency to hold back whereas the younger one, conversely, displayed a noticeable maturity with an abundance of spontaneity.

When the Second World War worsened it was decided that Princess Elizabeth, who was deeply affected by its trail of pain and destruction, should be evacuated to Windsor Castle with Princess Margaret, or as it was explained publicly, to 'somewhere in the country'. In the event of bombs being dropped near the castle, dungeons would act as a safe haven. On the night that the princesses were safely installed at the castle a message came through to the Sheridans from Buckingham Palace, requesting that Lisa telephone in the morning to Marion Crawford, the princesses' governess, otherwise known as Crawfie. She duly explained that they were required for a day on a set date and to bring their cameras, just for fun.

At the castle, Lisa was met by the two sisters and led along to the schoolroom, which had once been Queen Alexandra's sitting room. There the day ahead was discussed in earnest with the governess. The princesses set about playing the piano and various games. They sketched, painted and read books whilst Lisa and Jimmy set their cameras up in a leisurely fashion. The corgis were very much in evidence as usual. Jane and her puppy Crackers were the star attractions that day and later, while Princess Margaret lay reading *The Children of the New Forest,* Jane snuggled up beside her in time for the click of the camera, which recorded the peaceful scene.

Studies taken on this occasion were combined with those taken at Royal Lodge in the spring of 1940 and used to illustrate a new book *Our Princesses at Home,* with text by Lisa Sheridan and photos by Studio Lisa, published by John Murray.

In July 1941, in the midst of that year's scorching summer, the Sheridans were summoned once more to Windsor. The pictorial record of this visit shows the princesses totally oblivious to the camera as they contemplated their curious new pet Casper the chameleon in the sun-drenched gardens. Princess Elizabeth sat at a table beneath the trees solving a crossword puzzle in French – part of a languages lesson. She was duly joined by

Inside the Welwyn Garden City studio. Lisa, seated on the stage, directs the lighting, while Jimmy waits behind the camera.

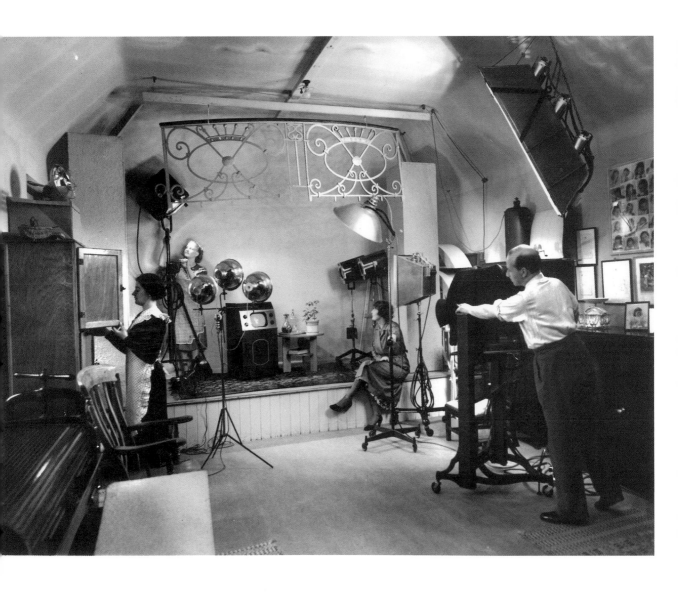

Princess Margaret and their mother, who frequently spoke in French with her daughters. The air was heavy with the sent of syringa from several of the huge bushes that provided an appropriate background to the images captured on that perfect day of high summer.

By December of that year, plans were well advanced for the pantomime *Cinderella* to be staged in the magnificent Waterloo Chamber at Windsor Castle. It would prove to be the first of four successive years of royal pantomimes in which the princesses and their local friends, largely evacuees from the London Blitz, wrote, staged and acted their own productions.

Princess Elizabeth would play Prince Florizel to Princess Margaret's Cinderella. They adored dressing up, dancing, and theatre of all description. The King entered enthusiastically into hunting for junk suitable for the amateur production. It was very much a home-made affair, improvisation being the order of the day. Jimmy was unwell and to his intense disappointment couldn't accompany his wife to Windsor Castle to photograph the dress rehearsal.

Fog had surrounded the castle that morning. Just as Lisa was about to leave home, one of the Queen's ladies-in-waiting rang through to say, 'In light of the rather doubtful weather conditions the Queen was of the opinion that you might care to bring along a suitcase in case the elements go against returning home late in the evening.'

Throughout the dress rehearsal the Queen, a thimble on her finger, sat ready to sew, stitch or mend the cast's clothing problems as needed. At one point everyone was startled to see Crackers, one of the family's corgis, emerge unannounced from beneath Princess Margaret's crinoline. With rehearsals over, quiet once again descended on the Waterloo Chamber. In the process of taking her leave, Lisa noticed two small figures dressed respectively in blue and pink woollen dressing gowns appear on the stage and come down the side steps. 'We have come to say goodnight,' the princesses announced and promptly held out their hands in doing so.

Much of Studio Lisa's royal photography during the Second World War was carried out at Windsor Castle as opposed to Royal Lodge. However,

one Easter during a bombing respite the Royal Family did manage a break at their favourite country residence.

It was a time when anything could happen to anyone at anytime. Army recruits visiting the house next door aimed wolf whistles over the wall into the studio garden as female models posed before the cameras. The Sheridans even found time to take in billets as war progressed. One evening Jimmy was knocked over by a motorcyclist and sidecar travelling without lights in the blackout. His injuries were severe and it was possible he might lose a leg. Once it was firmly encased in plaster, the inevitable happened: a message came requesting the Sheridans' presence at Royal Lodge the following day. Lisa knew how disappointed Jimmy would be, but his misfortune on this occasion turned in favour of Frank Price, the former eggman, then serving in the RAF. Frank was released from his wartime duties to accompany his employer to the King and Queen's retreat in Windsor Great Park.

Finding herself photographically on her own sent Lisa into a case of panic. She and Jimmy had always worked as a team - he was more often the cameraman and darkroom technician while she directed the shots by setting the scene, posing the subjects, adjusting the lights and so on. Then, by standing alongside Jimmy at the camera she would place her hand on his shoulder at the psychological moment for exposure. Now, apart from Frank's assistance, she was working alone.

There was one nerve-wracking moment when both thought that this particular assignment was jinxed. Upon arrival at Royal Lodge, Lisa had unpacked the cameras and connected the lamps as both indoor and outdoor photographs were to be taken. When she tested the lighting arrangements, the whole room lit up as expected, but suddenly there was a flicker and the lights slowly died completely. Lisa and Frank stared at each other with mouths open. The pair of them were utterly speechless. An electrician had to be found, and quickly. There were six not so far away at Windsor Castle. As this bit of information filtered through, one on the spot at Royal Lodge thankfully answered the call.

When the problem was eventually solved, indoor photography commenced, after which the King, suggested in very jovial spirits that his

family should all troop outside and indulge in a spot of practice with the stirrup pump – which was a commonplace activity for citizens throughout the country at that time, in case of incendiary bombs being dropped by the enemy. While the Queen stood by and supervised, King George and his two daughters engaged in riotous fun with jet and spray nozzles and buckets of water. When the stirrup pump drill became more hilarious Frank and Lisa took pictures from all angles. Despite the fun, it was obvious the Royal Family knew what to do in an emergency.

Still in a lighter vein the princesses were captured setting off for a cycle ride, before the mood changed and attention was diverted to affairs of state on that particular Easter Day. Officialdom had to be dealt with on a daily basis whether on holiday or not. The arrival of the scarlet dispatch boxes from London heralded papers for the King's approval and Lisa noted how earnestly he explained matters to his elder daughter.

Despite the initial technical problems the day had gone well, and concluded on a particularly memorable note. Lisa and Frank were all packed up and about to drive away from Royal Lodge when the two princesses, with a huge bunch of carnations plucked straight from the greenhouse, rushed over and pushed them through the wound-down car window, saying that their mother wanted them passed on to Mr Sheridan with her love and a wish that he might recover quickly. The message was a welcome tonic for the patient, lying in his hospital bed with the troublesome leg held high in splints. The royal carnations were pinned all over Jimmy's pyjamas.

Two months later he was still laid low, and to his annoyance had to forego Studio Lisa's next royal commission also. Lisa went off once more to Windsor to photograph Princess Elizabeth and Princess Margaret as Guides along with other members of their Guide company, who assembled every Tuesday at the castle.

Later that year a new book would be published by John Murray, again with words by Lisa Sheridan and images by Studio Lisa. *Our Princesses in 1942* contained a complete year's cycle, beginning with the beautiful summer of 1941 images at Windsor. The *Cinderella* Christmas pantomime pictures from the end of that same year were likewise included, as were the

Royal Lodge interior images plus the stirrup pump and cycling scenes of the following April.

By the end of the year Jimmy had recovered enough to join his wife in photographing another Windsor Castle Christmas pantomime. This time it was *Sleeping Beauty*. Princess Margaret played Fairy Thistledown whilst her sister, as Prince Salvador, sang solo numbers and led the chorus in 'Jingle Bells' and 'Ma! I miss your apple pie'.

Lisa and Jimmy were privileged to witness at first hand a very behind closed doors view of the Royal Family. Especially noticeable was the affinity between the King and his first-born. The essence of this mutual admiration was outlined in a letter Lisa wrote to a friend the day after she and Frank Price returned from Royal Lodge.

She noted the obvious bond of understanding that clearly existed between the monarch and Princess Elizabeth. Of how he made a point of explaining everything to her personally, a kindly father to his attentive young daughter, the present King to the future Queen. Lisa also commented on the pair looking at papers on the King's desk while she took a photograph of them doing so.

Later she was touched by the sight of them walking in the garden as the princess put her arm around her father's waist. To her friend, Lisa mentioned how the couple shared what appeared to be funny little jokes between themselves that radiated a consistent type of good humour. This was evident whenever the chance to be together was taken. While somewhat constrained when in the public eye, Lisa supposed that father and daughter nonetheless, shared the type of companionship that was all their own. Perhaps this, she mused, was even deeper than might be found in the ordinary family so that behind the burdens of public scrutiny a close family life could thrive like it does for the rest of us.

On the occasion of the third Windsor Castle Christmas pantomime Princess Elizabeth took the part of *Aladdin*. Studio Lisa's pictures of her as lead boy are especially captivating. It so happened that *Aladdin* was the only one of the Windsor pantomimes which Prince Philip of Greece (later Duke of Edinburgh) would attend while on leave from the navy.

In May 1944 the Sheridans were unexpectedly summoned back to Windsor. Both princesses had won trophies for their horsemanship at the Royal Windsor Show and wanted to commemorate the occasion. Princess Elizabeth was photographed with Odd and Rolf, two Norwegian foal half-brothers which the King had bred in Scotland.

Princess Margaret, on the other hand, won a silver cup for the 'smartest utility cart' and posed with Gypsy who wore the rosette presented as part of the contest win. There were also pictures recorded of the Queen being taken for a ride by her elder daughter in Queen Alexandra's elegant pony cart, pictures with the corgis, as well as mother and daughter scenes in the spring sunshine that bathed the castle gardens.

Once more Lisa was writing and illustrating a new volume entitled *Princess Elizabeth at Home,* which featured images from each of the successive commissions from 1936 up to that present point in time. For this publication the Queen had consented to additional scenes being added of the princess in her private sitting room at Windsor Castle. Published in 1944, it was again a John Murray book, which was received with unanimous applause by a receptive war-weary public.

Before that year was out the prospect of photographing what was to be the final wartime royal Christmas pantomime was not so assured for Studio Lisa as it might have been. Up until then the Sheridans had enjoyed the status of being the only photographic organisation commissioned to photograph the pantomimes. This exclusivity met with 'Press' disapproval as any royal function at that juncture was normally handled on a 'your turn this time, my turn next' basis. It was decided that a meeting should take place to determine who should be given the privilege of documenting the fourth and last of the shows, despite Lisa and Jimmy's past involvement. After an agonising wait Queen Elizabeth's lady-in-waiting contacted the studio in Welwyn Garden City to say that the Queen had said that she would prefer to 'keep it in the family' and have Mr and Mrs Sheridan.

Finally it was *Old Mother Red Riding Boots* that bought the panto quartet to its end. The highlight of this presentation was the Victorian bathing ballet in which Princess Elizabeth appeared in a bathing ensemble from that period. So delighted was he with his daughter's appearance

Roger Moore, later a memorable James Bond, sharpened his earlier flair for modelling in front of Studio Lisa's cameras.

that her father especially requested a portrait of her in it. Lisa later made a painting in miniature of the resulting study which the King long cherished.

A fitting touch to the finale of all four royal pantomimes at Windsor Castle was a group photograph of the entire casts who had been involved in them. Everyone, including crew, musicians and so on, received a signed print as a momento and at the wind-up party in the castle's great Red Drawing Room, the princesses personally waited on everyone.

Both the Sheridans were convinced that they had well and truly served their purpose in documenting the Royal Family prior to the accession of King George VI and throughout the devastating years of the Second World War. Time would prove such a diverse record of the sovereign's family home life away from the glare of media coverage to be unique, more so because of the time frame in history that it covered.

'The King is dead'

Taking stock of where they were now at, Lisa and Jimmy turned their attentions once more to run of the mill commercial work at the studio in Welwyn Garden City. As the world slowly came to terms with peace, family life at 14 Parkway also began adjusting to changes of its own. Jimmy, for instance, was learning to live with an increasing reference to himself as 'Mr Lisa!' His daughters had grown up and left home, while general work under the Studio Lisa banner gathered a new momentum. The bedrooms vacated by the girls were gradually taken over and incorporated into the workings of the studio itself.

'Jill', at the end of the upstairs landing, was filled with fireproof steel cabinets for the safe housing of thousands of negatives whilst 'Dinah', overlooking Parkway, became a stationery room and storage for large presses used in the mounting and finishing of photographs.

During a short holiday at Sandgate in Kent the photographers had seen a house for sale at nearby Hythe. The Admiralty had possessed it during the war and the door of every room had a plaque bearing the name of a

famous battle. Lisa and Jimmy decided to buy the house and to call it 'Lilibet' after the King's pet name for his elder daughter. When in 1952 she became Queen Elizabeth II they felt the name to be irreverent so altered it to 'Limpet'.

The Sheridans considered this new seafront bolthole with its unrestricted view over the English Channel to be the perfect location house, subsequently using it as the focal point to illustrate holiday brochures and the advertising of seaside resorts.

Meanwhile, back in Welwyn Garden City, Lisa's interest in human psychology had extended to the formation of what she called 'The Salon' or 'Kulture Klass'. These Thursday evening meetings had been established during the war years and consisted of six to eight couples. On the nights in question the subjects to be discussed that evening would be passed to each couple. They in turn would be required to give their views on these and other thought-provoking topics.

'Do you consider yourself an introvert or an extrovert?' Lisa would ask. Such conversation pieces, and the getting together of evenings to dissect them typified Lisa's adventurous thinking.

'Normality' in whatever form was now a thing of the past for the Sheridan family. Not only local identities, they had also become nationally known for their work and the trading name under which it was achieved. This automatically set them apart. Day-to-day studio work could never be totally without constant reminders of those that had become the photographers' most famous clients.

Aside from recording an informal, behind the scenes look at the foremost members of the British Royal Family, Studio Lisa's cameras had also focused on the infant son of the Duke and Duchess of Gloucester. Between 1939 and 1945 the Gloucesters spent numerous sojourns at Barnwell Manor, the country house they owned near the quaint old greystone town of Oundle in Northamptonshire.

In 1942, when Jimmy was still in hospital, Lisa went to Barnwell to photograph the Gloucesters' first child, 8-month-old Prince William. A lily pond divides the manor from the nearby ruins of thirteenth-century Barnwell Castle and it was here that the 40-year-old duchess

was photographed with her baby son. When the child was 18 months old, Lisa and her assistant were recalled to Barnwell Manor as the duke was home briefly on leave and the family wanted to record their being together.

Leaving Barnwell by car after that assignment became something of a hazardous affair. A town in the vicinity had already been bombed that afternoon. Compounding this problem, not three miles from the Gloucesters' home a plane resembling a ball of fire crashed onto the road in front of their car.

Alarmed by the intensity of the heat, Lisa reversed quickly before she and her companion crawled from the vehicle and lay on the road behind it pondering what move to make next. Eventually, regaining their car and having opted for a wide detour, they made it back to Welwyn Garden City with the royal negatives, about which they had held the gravest fears, still very much intact.

When Prince William was next photographed at Barnwell he was 2½ years old. Pictures taken on that occasion combined with the previous two commissions made up the illustrative content of another Studio Lisa book. *Prince William of Gloucester* was published by Angus and Robertson Ltd in 1945, the year Prince William's younger brother Richard (later a Studio Lisa subject) was born.

The year after this book appeared the royal photographers were to be found recording the King's family for the first time since the end of the Second World War. A new publication in what was rapidly becoming a very desirable and sought after series was appropriately titled *Off Duty*. It showed the monarch and his daughters enjoying a variety of pursuits in the garden and beside the pool at Royal Lodge. Other images portrayed the royal sisters in their private rooms at Buckingham Palace where, among other activities, we catch a glimpse of them attending to their correspondence, arranging flowers and playing the piano. The underlying interest of these photographs is very definitely in the revelation of what the princesses' own space looked like in terms of home life behind closed doors and the style of surroundings in which it was conducted. Scenes such as these were something of an eye-opener. Loyal subjects around the

A study of the Sheridans' grandson Jeremy Hanley, future Conservative Party Chairman and Knight of the Realm.

world were left with the rather startling realisation that Royal Family life was not perhaps so far removed from themselves after all.

As much as a pattern had started to emerge with Lisa's *Off Duty*, published by John Murray in 1947, so too, was public awareness continuing to gather momentum concerning the photographic activities that stemmed from the depths of hers and Jimmy's lovely garden in Hertfordshire. When it became known that the pair had repeatedly photographed royalty, all sorts of celebrities found their way to the studio. Friends and relatives pressed Jimmy and Lisa into opening a London studio to scoop up the lucrative society market that they would be sure to capitalise on. It says much for their respective characters that they would shun all such suggestions. Sacrificing the unconventional freedom of their studio in a garden in favour of cosmopolitan glitz and glamour was never high on the Sheridans' list of priorities.

That said and done however, and coinciding with the end of the 1940s, there came an ever-increasing demand for their studio services. To accommodate such growth it was decided, after much thought, to open a London Library of Studio Lisa photographs. Situated at 30 Fleet Street it was billed as 'The most comprehensive library of photographs in the United Kingdom', satisfying a client demand for illustrated pictures covering every conceivable purpose. Agents were established throughout the world in countries as diverse as Scandinavia and South Africa, New Zealand, Germany and France.

The library's rapid success meant that larger premises soon had to be found. These were located in Grape Street, High Holborn, this time incorporating the studio facilities so long resisted for a London base. As a commercial enterprise it was more than adequate, being staffed and operated as a completely separate unit from head office in Hertfordshire. Advertisements of the time promoting their portraiture and illustrative work stated 'better known nationally than locally'.

It all seemed a far cry from the days in Broadstairs when the filing system consisted of a drawer with four cards headed Indoors, Outdoors, Animals and Cookery. Monthly bills back then, for photographic supplies, spelt out that what they were attempting was in fact way beyond their means. In those days Jimmy had been philosophical when he stated, 'What's

Granddaughter Jenny Hanley, a little before her time as model, actress and children's television presenter.

the point of spitting against the wind' (an old Russian proverb) and 'to harbour one's resources is not always the best way to economise.'

By now Princess Elizabeth had married Prince Philip of Greece. Lisa was working in her office one day in February 1952 when the door opened and there stood Enid, one of the studio assistants. She was white and stunned.

'Enid, is there something the matter, are you alright?'

'I've just been listening to the darkroom radio. The King is dead. Princess Elizabeth is now Queen.'

It was hardly believable but true. In the sadness that followed, Lisa and Jimmy with the studio staff went back over the years since 1936, reliving the memories by way of the photographs they had taken. Recollections of the love, laughter and togetherness enjoyed by the late sovereign and his family were all around them. Their hearts went out to his widow and her daughters.

The Queen and Her Children

Thankfully, the coming springtime slowly but surely brought a lifting of spirits in the form of an invitation for the photographers to revisit Barnwell to photograph Prince William and Prince Richard of Gloucester.

In September of that year Lisa and Jimmy went to their Kentish seaside home at Hythe to relax and recover from a strenuous workload. On the first day of this holiday the telephone rang. It could be heard from across the road as the pair lolled on the beach directly in front of the house. Rather than leave it to ring, something told Lisa she should make the effort to answer the call. It was her secretary phoning from Welwyn Garden City, explaining that a royal letter had arrived. It contained a special request from Her Majesty The Queen enquiring if Mr and Mrs Sheridan could travel to Scotland to photograph herself, Prince Philip, Prince Charles and Princess Anne at Balmoral Castle. The request reached the holidaymakers on a Monday. The Sheridans packed up and returned immediately to

Hertfordshire to prepare equipment and to arrange the unexpected purchase of the local window cleaner's van, as their own vehicle had inconveniently developed a problem that rendered it unusable. By Friday of the same week, with 'Studio Lisa' hurriedly painted on the side of the van, photographic paraphernalia loaded aboard, the couple set out for Scotland, full of anticipation.

Queen Elizabeth II had inherited a love of her highland home on the banks of the River Dee from her great-great-grandmother, Queen Victoria, who built it. Some of her happiest memories originated at Balmoral and the photographs about to be taken there, in the autumn of 1952, typified some of the most satisfying.

This was the first time the Sheridans had seen the young Queen, her husband and their small children together. Lisa would recall an obvious bond of affection between this family of four that was loving, natural and spontaneous. Prince Charles and Princess Anne didn't have to struggle for attention because it was freely given by both parents.

Like her mother before her the Queen proved to be extremely helpful with photographic suggestions and had already developed a keen interest in photography. The sunken garden at Balmoral provided a picturesque setting for a diverse selection of sittings. These included the monarch with an effervescent Princess Anne aged 2, with her doll's pram, and a more receptive, thoughtful, 4-year-old Prince Charles with his pedal car. Other incidental studies showed the new sovereign and her corgi Susan. One especially delightful shot of the family on the steps down to the sunken garden appeared on the Queen's private Christmas card for 1952, a matter of some pride to the photographers.

Attracting the children's attention had not been easy. They were engaged in an animated game of trains. Calling them, the Queen suggested that if she became the station master they could 'puff puff their engines around the garden once more and arrive at the platform beside her and their father'. They obliged.

The 'piece de resistance' of the session occurred when the Sheridans captured Queen Elizabeth hauling Prince Charles into her sitting room window. It had been agreed that a family group in a window setting

Letterhead details
from the early
1950s.

LISA SHERIDAN, Director
J. A. SHERIDAN, F.I.B.P,
Director & Secretary
WELWYN GARDEN 850

Studio LISA
LIMITED
WELWYN GARDEN CITY

LONDON OFFICE
30 FLEET STREET
E.C.4
CENtral 7640

would be attractive. The Queen leaned out of the selected window to speak to her children in the garden. The young prince, noting a wire trellis, climbed onto it the better to leg himself up with some help from his mother. From a nearby ledge he triumphantly turned to watch his little sister attempt to emulate him. Suddenly he jumped back down into the garden and heaved Princess Anne up with a short sharp shove. This unrehearsed sequence of events proved to be a pictorial success worldwide.

Later as the royal children posed with their mother on a white garden seat, Lisa couldn't help but muse on the fact that the little girl she had first known as a 10-year-old was know about to be crowned Queen. It seemed to the Welwyn Garden City photographers that she had changed very little along the road from childhood to sovereignty.

The studio staff were as delighted with the Balmoral pictures as the subjects themselves. With the Queen's permission Lisa was able to write and illustrate a new John Murray book, which, after numerous headaches, caused by hurrying it through in time for the Coronation in June 1953, became a huge success entitled *The Queen and Her Children*.

Towards the end of 1953 the Queen and Prince Philip departed on their long five-month Coronation tour of the Commonwealth. A week prior to their return in April 1954, Lisa and Jimmy were invited back to Royal Lodge. Prince Charles and Princess Anne had been living there under the watchful eye of their devoted grandmother. Besides other adventures in the grounds of that happy home, the young brother and sister played contentedly in the Little Welsh House exactly as their mother and Aunt Margaret had done almost twenty years before. Documenting these activities in *Playtime at Royal Lodge*, another delightful John Murray book she wrote and illustrated, Lisa explained how busy the children made themselves by doing household chores inside the tiny cottage. Princess Anne made quite a play of putting

an empty pie dish into the oven and then went through the motions of washing her hands without soap or water in the sink. Her brother received an imaginary phone call before stepping outside to announce, that he is the father in this home, whereupon his sister as she joined him with a kitchen broom, declared that she was the maid.

Pictures were taken on the terrace of the children with the Queen Mother. She was urged by the youngsters to recount the story of how their own mother and Margot (as they called Princess Margaret) played in the same garden when they themselves were little girls. Recalling the undeniable affinity between the late King George VI and his elder daughter, Lisa and Jimmy were quick to perceive a similar parallel between the Queen Mother and her eldest grandchild Prince Charles. The mutual admiration so evident then was to continue unabated over the years, enchanting royal watchers.

Following scenes with the corgis, the children were recorded playing among the daffodils where Princess Anne made it known she would pick some of the flowers to place on the tea table.

The photographic content of *Playtime at Royal Lodge*, the eighth pictorial book in the Studio Lisa series, prompted one reviewer to state: 'A collection of the most informal royal photographs ever published. Here is proof that their lives and ours are not, as in generations past, poles apart.'

Much to the credit of the Sheridans, when the Queen broadcast her first televised Christmas message in 1957, two framed photographs of Prince Charles and Princess Anne from this latest collection were clearly visible on her desk.

Lisa Sheridan's long-awaited autobiography, *From Cabbages To Kings* appeared in 1955, published by Odhams Press. The dust jacket explained that this was the life of the distinguished photographer, 'whose work, particularly that of the Royal Family, had been seen by millions'.

Despite success and the fame that went with it, both Lisa and Jimmy continued to take their achievements very much in their stride. Both now in their 60s, they could look back on a lifetime of huge highs mingled with the inevitable disappointments and frustrations. As a family unit they had remained close. Both Jill with her young sons, Anthony

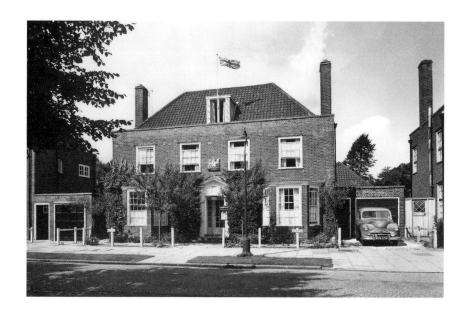

Studio Lisa displaying the Royal Coat of Arms in Parkway, Welwyn Garden City. The flag flies on the day of Princess Anne's 4th birthday.

and David, and Dinah with her two children, Jeremy and Jenny, lived nearby. The three grandsons featured frequently as models in many of their grandparents' illustrative photographs, to say nothing of blonde mercurial Jenny, the only granddaughter. Demands upon her time before the camera were fairly consistent, leading eventually to her becoming a noted model, actress and children's television presenter.

In the latter half of the 1950s Lisa and Jimmy's days in Welwyn Garden City were numbered. Emphasis on the London studio was becoming increasingly apparent, as was the desire of its founders to find new interests, which they sought more and more beside the sea at 'Limpet'. It was there in June 1958 that Jimmy suddenly died of a heart attack. Not only did his demise bring to an end a harmonious business partnership, but an irreplaceable friendship with the woman he had married and with whom he had shared a love that had lasted a lifetime. Saluting him, the Institute of British Photographers wrote in a letter to his widow that, 'Photography as a whole had greatly benefited by his contribution.'

Lisa was ill-prepared for the finality of losing her husband, a situation she had never consciously contemplated. To help with the initial impact, she took refuge alone in the peaceful, soothing countryside of Dorset.

Emerging eventually from this self imposed solitude she explained to Dinah, 'You know, I never realised how difficult it would be planning a meal just for one. The best solution I think is to cook a very large chicken, and go about eating it in as many ways as possible.' Thirty-years earlier at Castle House the mere idea of a chicken shared by four, let alone one, had been a luxury seldom contemplated. At that point in time, stretching a limited budget to accommodate the rent money plus a passion for amateur photography, Lisa would prepare one solitary chop for Jimmy as he travelled home from London's Cannon Street station to Broadstairs on the evening train.

'Where's yours?' he would ask as he sat down to his meal.

'Oh I couldn't wait, I've eaten mine,' his wife would untruthfully reply.

Never one to be idle at the best of times, least of all now, Lisa steered herself back into photography and life in general with her customary sense of urgency. Almost one year later, in the summer of 1959, she found herself undertaking a return visit to Windsor Castle to photograph Princess Anne, now aged 9, with her mother Queen Elizabeth II.

Crimson and yellow roses that climbed the ancient grey stone castle walls provided an appropriate backdrop for the initial studies taken for that particular commission. Then the subjects changed into riding attire and the scene moved to Frogmore Gardens where the young princess was photographed on her Welsh-bred strawberry roan pony, Greensleeves.

Lisa had always had a fascination for back-views - she believed they helped to characterise the individuals concerned. With this in mind she recorded the Queen and her daughter busily untying a dinghy at a Frogmore lakeside mooring. The result was appealing and went on to score an instant hit with the public because it hinted at a feeling of casual familiarity still somewhat novel in royal photography of the day.

Inevitably the corgis found their way into these shots as well. Along with other photos taken a few days later of Princess Anne in her Brownie uniform with members of her Brownie pack in the grounds of Buckingham Palace, they formed a new John Murray volume, entitled *The Queen and Princess Anne*, which appeared later that same year.

Never Look Back

Twelve months on in August 1960, the monarch's mother celebrated her 60th birthday, which prompted an invitation to Lisa requesting her presence for the first time at the Queen Mother's London home, Clarence House. Standing in its picturesque secluded gardens, Lisa rightly supposed that her flair for outdoor photography was exactly what her sitter had in mind for her birthday portrait. A keen gardener herself, the Queen Mother took considerable trouble explaining to Lisa how and why she liked a hand in the design of her own gardens where possible.

Later, with the cameras set up indoors, there were comical scenes when the Queen Mother attempted to pose her two corgis Bee and Billie

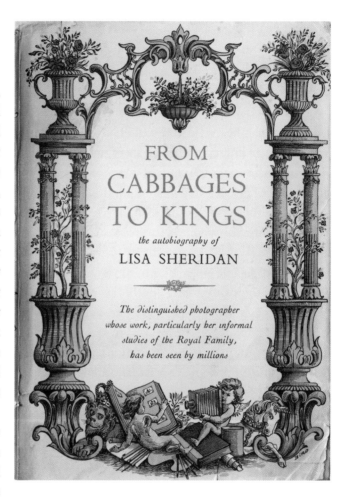

The cover of Lisa Sheridan's 1955 autobiography.

with her dachshund Ricky on a brocade couch. The three dogs had previously rushed into the room ahead of their mistress, hastily inspected the equipment then barked madly before scuffling off only to return equally as swiftly with their devoted owner. Several attractive studies were taken that day inside Clarence House as well as in the garden.

In spite of all the pictures she had taken of the Queen Mother over the years, Lisa had never felt that she had entirely captured the vitality or radiance of her subject's expression. The 60th birthday studies provided the solution with a particularly enchanting interior portrait framed by a simple window setting. Lisa knew she had finally, with the aid of natural

> *This book was approved by Her Majesty the Queen who most graciously scanned the manuscript word for word before anything was printed.*
>
> *Lisa Sheridan*

When a copy of *From Cabbages to Kings* was found in a specialist bookshop, the Queen's approval of its text was noted on the inside front cover by the author.

light, recorded the true essence of her much loved subject. Although not prone to displaying examples of her own work in the homes that she lived in, Lisa Sheridan allowed herself the enjoyment of this photograph on a desk in her office.

Curiously enough, Her Majesty Queen Elizabeth The Queen Mother's 1960 portraits did not appear in book form. In three decades of royal photographs bearing the Studio Lisa insignia there were only two other sittings that weren't presented as a published bound volume. These would be Queen Elizabeth II with her third son Prince Edward as a baby in 1964, followed by Prince Andrew and Prince Edward late in 1965.

As the work of Studio Lisa was now associated worldwide with the British Royal Family, one might reasonably ask how a reputation such as Lisa Sheridan enjoyed could be further enhanced. The answer became apparent with the publication of *A Day with Prince Andrew*, published in 1962 by Hodder and Stoughton.

It was a major sensation, prompting glowing reviews and propelling the 65-year-old grandmother into the media spotlight. All the praise was justified. Any barriers of formality that had yet to tumble in terms of royal portraiture up to that point in time were completely down. The images were proclaimed worldwide as the most spontaneous royal illustrations ever published.

Responding to countless queries about her work at this time, and the pictures of Prince Andrew in particular, Lisa made it plain that she didn't exactly make a fortune out of photographing royalty. She just sold her pictures on to photo agencies at normal rates as other camera buffs would do.

Reflecting on the spontaneity shown in the images of the little prince, aged 2½, Lisa noted that she believed it was the right age to photograph a child – they are usually full of showmanship, not in any way self-conscious and invariably obliging thanks to the attention being heaped upon them.

Prince Andrew's pictures were all taken in the glorious spring of 1962 on the terraces and in the gardens of Windsor Castle. Interior shots were recorded in the child's nursery at Buckingham Palace. As a photographic subject the boisterous little prince was a natural, so much so that Lisa found that she and her assistants actually had to wait for a quieter mood to show what might prove to be his more angelic persona. He revelled in being the star attraction, constantly displaying a change of expression. Hunching his shoulders in delight, he would place a diminutive fat finger across his mouth and say, 'Ssssh' as his teddy nodded off head down in the crook of his arm.

In the Buckingham Palace nursery Prince Andrew's favourite toys were most certainly his wooden lorries, but Lisa observed with interest the enthusiastic enjoyment derived from a rocking elephant made for him by Prince Charles in his school carpentry class. The child also displayed a natural ease when romping with the royal corgis for whom there was always a bowl of water at the nursery door.

Like the books that preceded it, *A Day with Prince Andrew* was published with the Sovereign's authority. Prior to publication the manuscript and illustrations were submitted as usual for the Queen's approval. Corrections made in Her Majesty's own hand accompanied the draft's return to Lisa and the publishers, who amended it before the completed presentation was passed to the printer.

Public reaction to *A Day with Prince Andrew* was one of continued international delight. The ultimate accolade came when New Zealand issued a series of Health stamps in September 1963 depicting the young prince in scenes from the series of photographs taken.

New Zealand
postage stamps from
1963 carried Studio
Lisa's portraits of
Prince Andrew.

Such a seal of approval was as much a triumph for the Studio Lisa team as it was for the talented woman whose name had now become a household word, synonymous with photography of the highest order.

In the following year on 10 March 1964, Prince Edward, the last of the Queen and Prince Philip's four children, was born. Some months later the placid infant with his mother and 4-year-old brother gathered at Buckingham Palace in front of Lisa's camera.

The resulting photographs, although candid, informal, and equally as captivating as the previous series were fewer in number and therefore did not constitute a book devoted especially to them. Nevertheless, Lisa had numerous other commitments that same year to keep her pen and typewriter busy. Since Jimmy's death she had constantly refused any requests to share a home with either Jill or Dinah and their families, preferring her solitude as a means of pursuing her many activities and interests. At home and abroad her varied articles and features illustrated with Studio Lisa images were in demand by publishers in Europe, America, Canada, South Africa and Asia. She was also in a television documentary with photography as its basis, finding yet more time to write plays for that medium and radio as well.

In the last year of her life, the pace of Lisa's daily routine was relentless. She was happily addicted to entertaining friends, theatre visits, art galleries and antique exhibitions, even keeping up with her daily swim from May to October. Asserting that she had only ever spoken coachman's Russian she decided to take lessons in classical Russian as well. Whenever possible, she visited her London studio, where her active interest was a constant catalyst to the staff who never failed to be inspired by her.

The old home in Welwyn Garden City with its now white washed studio in the garden was consigned to the past. Sold to non-commercial interests the house again would become a family dwelling. Sensing the wrench Lisa may have felt when finally turning her back on 14 Parkway, the new owners wrote to her in Hythe suggesting that at any time she wanted to visit, there would be no one more welcome. In her return note of appreciation the photographer wrote: 'That chapter of my life is now closed, I have no wish to return, thank you.'

October 1965 found 'Aunt Lisa', as she was now known to the royal children, in the gardens of Buckingham Palace photographing the 18-month-old Prince Edward and his 5-year-old brother Prince Andrew. It was a bleak, overcast day, brightened by the antics of the young royal brothers as they romped around the leaf-strewn ground, swung from the trees, played by the lake and tumbled with the corgis. It was quick action material, all totally unrehearsed.

The cameras used by Studio Lisa had for many years been 5x4 Speed Graphics, and half-plate Linhofs. After the war when the Sheridans had taken on new staff, younger members persuaded them to use a Rolleiflex, although for a long period the larger format cameras remained in favour.

Three cameras always accompanied the photographers on royal assignments, one loaded with Ektachrome colour, one with black and white, plus a third always loaded in case of emergency. Lisa preferred fast film, particularly Tri-x or HP3. Certainly anything slower would never have coped with the poor light conditions for that final royal commission in the grounds of the monarch's London home. On that occasion it was down to one twenty-fifth at f/5.6 for many of the shots.

If anything, the diverse array of photographs taken that day of the untiring little princes were more natural than ever, a fitting finale to a career of photographic perfection for the woman responsible for them. As a book these images would doubtless have made a huge impact on the public, possibly rivalling the popularity of *A Day with Prince Andrew*, but it was not to be.

Although looking nowhere near her age (she was loath to admit how old) which she held at bay by an outward appearance of general fitness, it remained a fact that Lisa Sheridan had been successfully hiding a troublesome heart ailment for two years or more. By the power of positive thinking, a process she highly approved of, Lisa had become convinced that every pill prescribed by the doctor would undoubtedly be a cure.

One Saturday morning, Dinah, unable to reach Lisa by phone, drove down to 'Limpet'. There she found her mother lying in the hallway by the front door. She had suffered a stroke. Beneath her, on the carpet, amidst the unopened mail, was a letter from the Queen saying that she felt all four children could be assembled for a photographic sitting in the near future if Lisa could suggest a date. Realising the impossibility of such a request, Jill and Dinah composed a reply and despatched it to Buckingham Palace. Ten days later, on 26 January 1966, Lisa Sheridan died in hospital at Folkstone.

During the last few years of her life, Lisa had devoted a good deal of time to the preparation of a new book. Initially called *Eyes, Brains and the Camera*, it would prove a fitting legacy. As a non-technical publication designed for the amateur photographer, it covered a step-by-step guide to the taking of satisfactory photographs using logical, essential ingredients, in order, as indicated by the title. In a section of this new book, Lisa told how visitors to her home noted that she displayed very few examples of her photographic work. 'There's only a couple I really like to look at,' she would explain. 'One each of the Queen and Queen Elizabeth the Queen Mother.' Both these were individually signed and framed.

Lisa kept family photos for her bedroom only, rather than clutter up the house with photographs everywhere. Images of a more sentimental nature would, for example, be pasted inside a regularly used cupboard.

Inside one of these above her kitchen sink, there was glued a photo of the Queen with her much-loved corgi Susan. The inner lid of her manicure box and another containing needlework were given the same treatment. Lampshades, Lisa pointed out, could likewise be turned into treasured momentos by printing a favourite photo on thin single-weight paper that would curve to paste on easily.

At the time of the author's passing the manuscript for this forthcoming publication was all but complete and ready for final editing. With a change of title to *Lisa Sheridan on Photography,* the book published by Max Parrish, made its appearance in late 1966 and was prefaced by Jill who wrote appropriately:

> I feel sure her active mind and artistic flair will extend to you through the pages of this book, the last written words of a truly wonderful person who did not tolerate insincerity or laziness lightly and failed to understand how boredom ever managed to enter anyone's life. She died at the age of 72 yet never became an old lady. She died as she lived ever young at heart.

Nearly three weeks later, on February 19 to commemorate the 6th birthday of Prince Andrew, pictures of the birthday prince and his younger brother from the last of Lisa Sheridan's royal assignments taken four months before were released for publication. In so doing, the thirty-year period of Studio Lisa's royal informality was quietly, but not without an element of ceremony, brought to a close.

The Royal Family, especially the royal children, had a real affinity with her. Lisa always maintained she would have stood on her head for them if it made them laugh for the camera. The laughter she created was nothing new. Three decades earlier in June 1936, when she and Jimmy first visited Royal Lodge to photograph the young Princess Elizabeth and Princess Margaret Rose with their dogs, the Duchess of York had requested a particular family photograph. Gathering her two daughters about her, she had turned and asked for their father.

'Where's Bertie? We must have him as well.'

Dinah Sheridan with the author outside Studio Lisa's London premises in Grape Street, High Holborn, in 1971.

The author
in the former
studio garden
at 14 Parkway,
Welwyn Garden
City, Hertfordshire,
post the Sheridan
years.

Thinking she was asking for another canine friend, Lisa enquired, 'What breed are you looking for ma'am?' Everyone dissolved into laughter. In later years Lisa adored telling this story in reply to numerous queries about how she was able to be so relaxed in the presence of royalty.

Studio Lisa's Grape Street establishment in London's Holborn survived well into the 1970s when the leasehold of its premises was taken over by Camera Press Ltd, the international photographic press agency, as an extension of their offices and processing department.

Don Chapman, who had retired in 1990 as managing director of Camera Press Ltd, left a fascinating insight into the behind-the-scenes activity relating to the distribution of one of Studio Lisa's most successful royal picture releases:

It was 1952 when I was asked by my boss, Tom Blau, founder and owner of Camera Press Ltd, the international photographic press agency, to visit Studio Lisa in Grape Street in order to make a selection of photographs showing Her Majesty The Queen, Prince Philip and their two young children Prince Charles and Princess Anne. These photographs were for distribution overseas in connection with Prince

Charles' 4th birthday on 14 November. The pictures were taken at Balmoral Castle and depicted Charles and Anne wearing identical outfits, corduroy trousers and cardigans over woollen jerseys. The princess was shown with a doll's pram while Charles was seated in a toy car playing with a white fluffy glove puppet.

Mrs Sheridan appeared to be very composed and kind when I arrived even though there was a lot of activity and excitement because other members of several photographic agencies were present making their own selections from photographs on display. The press secretary to Her Majesty The Queen had made an arrangement whereby official photographs of the Royal Family would be made available to overseas publications embargoed for release on a set date and distributed through the leading London-based photo agencies on a non-exclusive basis. This arrangement made certain that even very small newspapers and magazines received the photographs at the same time as those with large circulations. The commissioned photographer would make his or her own arrangement similarly embargoed with a publication date to the British press. To a lesser degree this system has been in use ever since.

Recalling the later years when Camera Press Ltd occupied the Grape Street premises, Don continued:

I was to make almost daily excursions to Grape Street in the few years we used the building. On one of these visits I was directed by The Lord Chamberlain to remove the two 'By Royal Appointment' warrants from the windows which I did with the aid of a pen knife scraping the transfers from the inside of the glass. So ended an era, but Lisa Sheridan's photographs live on.

Of her life as a photographer Lisa had said she could never be entirely satisfied with her achievements. Whilst there had been opportunities gained, there had been those let go and wasted.

'With Compliments', showing both royal warrants.

When turning her back on her home in Welwyn Garden City, the house, the garden and the studio that had been her life there, she sold almost every piece of furniture in it. Her motto was to never look back, only forwards. It was the same with photography. Forging ahead to meet new challenges was always important to her. She warned though, that being a photographer was basically no different than any other career. Complacency must never enter into it, and at all costs one should remain humble. The ability to succeed rested on the knack of self-criticism and this, as Lisa liked to point out, was worthy of being rated one of the greatest attributes of all.

THE ROYAL SITTINGS

THEIR ROYAL HIGHNESSES THE DUKE AND DUCHESS OF YORK WITH HRH PRINCESS ELIZABETH AND PRINCESS MARGARET ROSE

Royal Lodge, Windsor, 1936

With the taking of this series of photographs, Studio Lisa ushered in a completely new visual dimension in royal photography. The formal air of detached aloofness, which the public hitherto had become familiar with, became a thing of the past.

The York's country retreat within Windsor Great Park is the setting. Here we see Princess Elizabeth, aged 10, with her younger sister Princess Margaret, aged almost 6, and their parents. Royal Lodge was always the 'family home.' It was here on Easter Saturday 2002 that Her Majesty Queen Elizabeth The Queen Mother, as the Duchess of York became, passed away aged 101.

The pets we see here include corgis Jane and Dookie, Choo-Choo the Tibetan lion dog and the Duke of York's creamy-yellow labradors Mimsy, Stiffy and Scrummy.

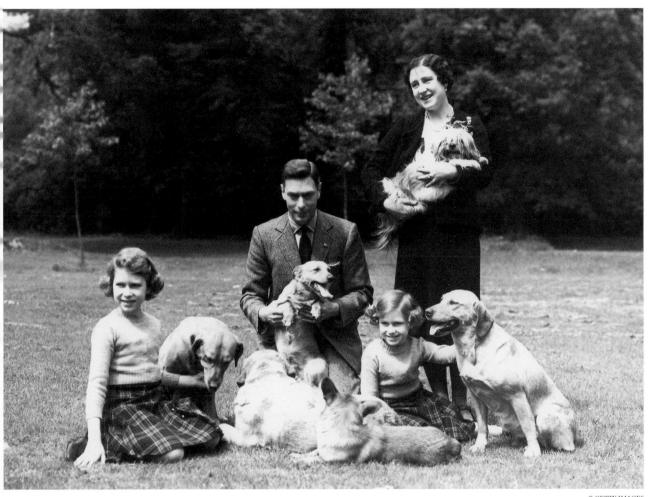

Some of the activity takes place in front of Y Bwthyn Bach (The Little Welsh House), a tiny thatched six-room cottage with hot and cold water presented to Princess Elizabeth by the people of Wales on her 6th birthday in 1932. Over the years the Duchess of York, as Queen and Queen Mother has been entertained there by her children, grandchildren and great-grandchildren. Returning to 'The Little House' on the occasion of her 90th birthday in 1990 the Queen Mother laughingly recalled 'I've eaten some awful meals in here.'

A few days following the Royal Lodge photographs being taken the scene moved to the York's London residence at 145 Piccadilly, which some years later took a direct hit by a Second World War bomb and was demolished.

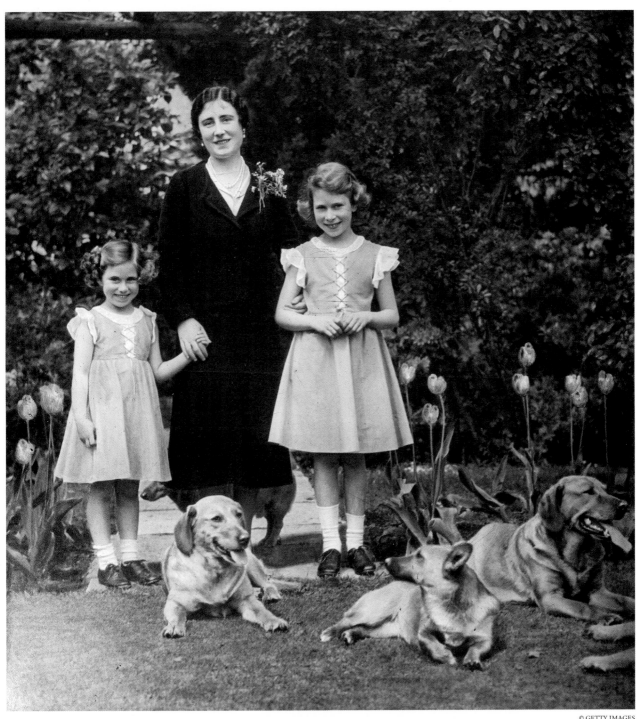

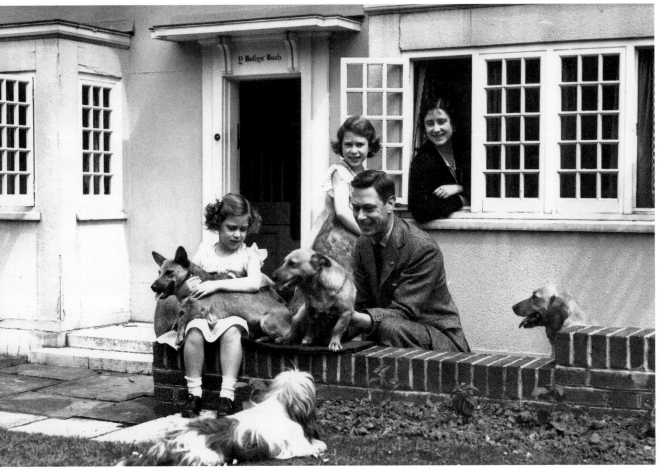

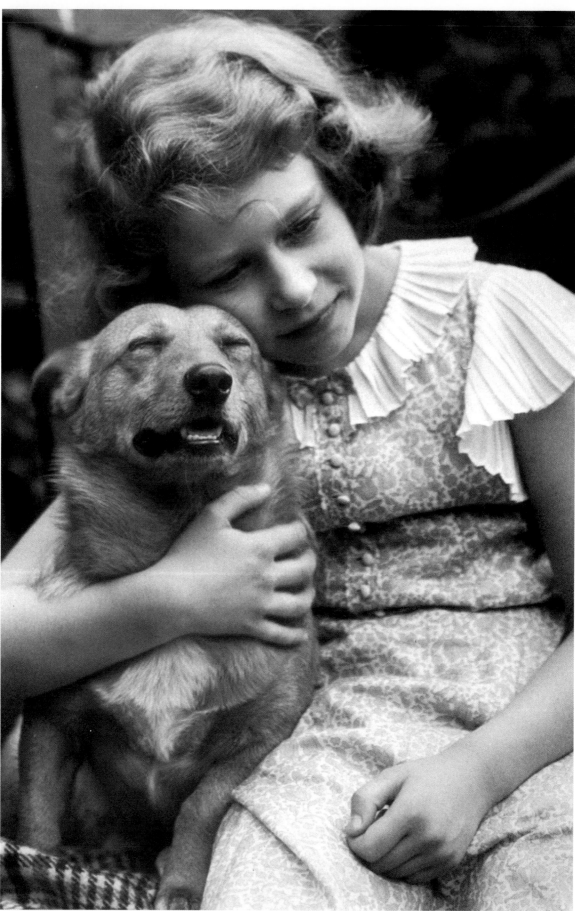

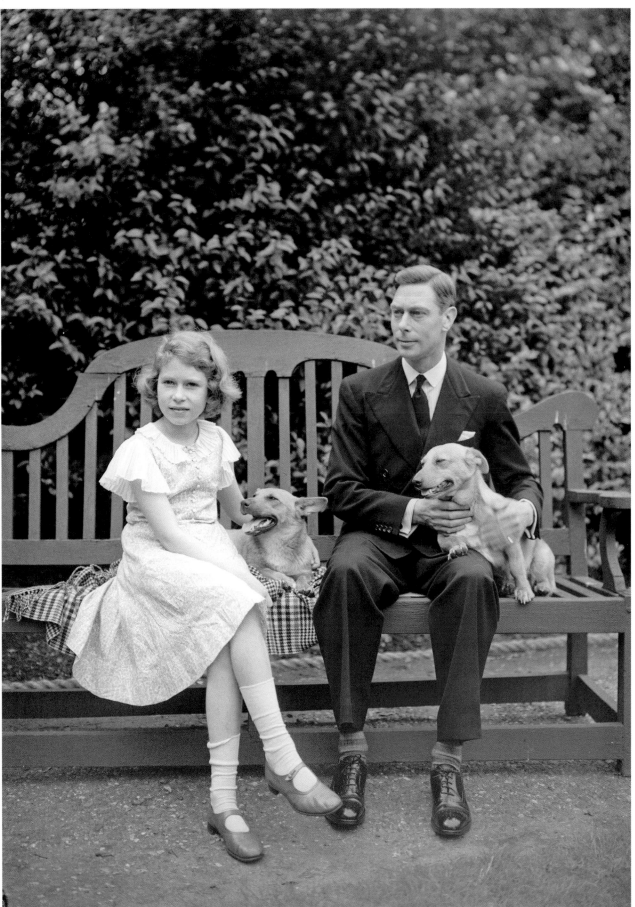

PRINCESSES AT HOME

1940

During the first year of the Second World War the Sheridans were invited to photograph Princess Elizabeth and Princess Margaret as identities in their own right. The setting was again Royal Lodge as it had been four years earlier. The monarch's daughters were now 14 and 10 years of age respectively and life was far less carefree than it had been in 1936. In and around the family's rural idyll in Windsor Great Park the trappings of ceremonial life and officialdom could be shed. This new pictorial record was therefore geared to be indicative of two young, high-profile lives, viewed as far away as possible from the more generally published scenes of recognised pomp and pageantry.

As if to spell out the unaffected informality of Royal Lodge life, the Queen particularly wanted photographs of the sisters following pursuits that they especially enjoyed. Corgis Jane and Dookie featured again along with puppies Carol and Crackers born the previous Christmas. Water bowls marked 'Dog' were placed alongside favourite chairs and beneath occasional tables, which underlined the feeling of homeliness that could be found throughout Royal Lodge. Lisa and Jimmy Sheridan noted how the personal belongings of those who resided at Royal Lodge were haphazardly scattered around the home just as they would be in countless dwellings throughout the land lived in by the King's subjects.

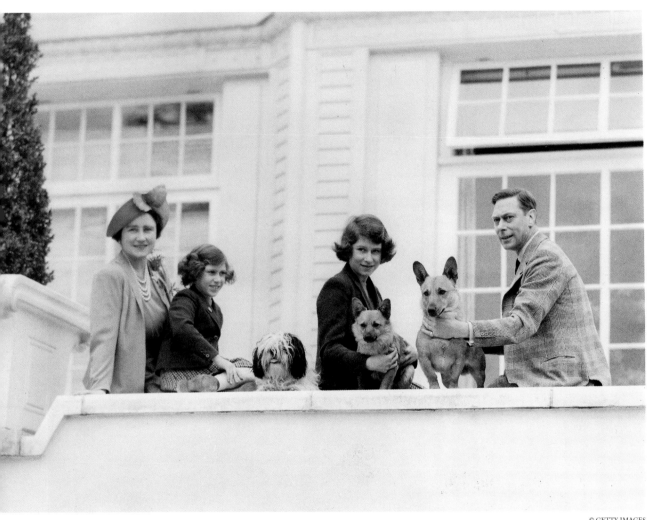

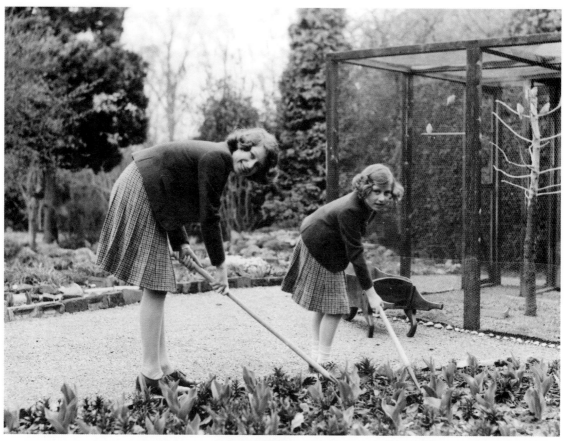

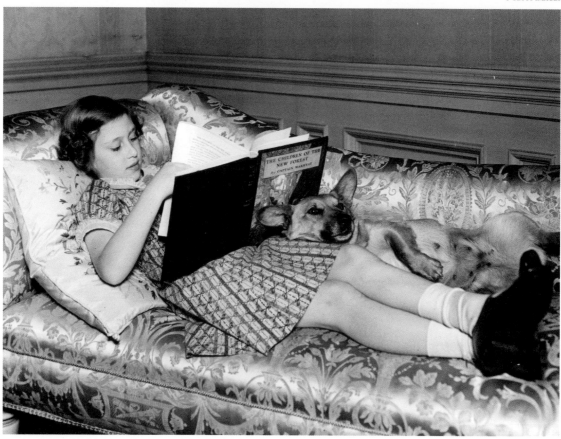

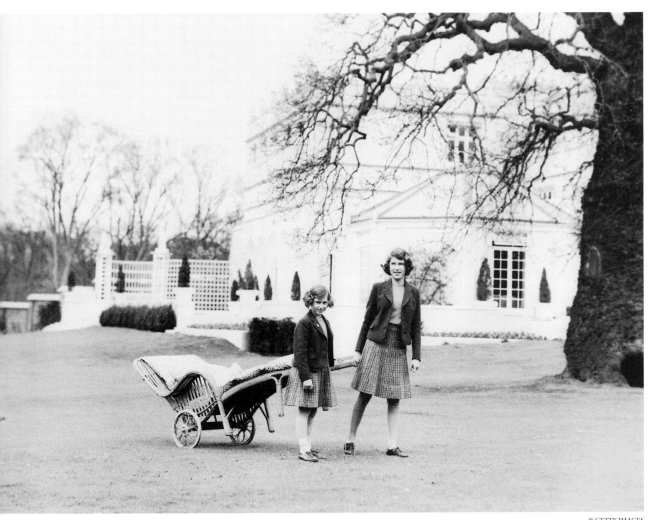

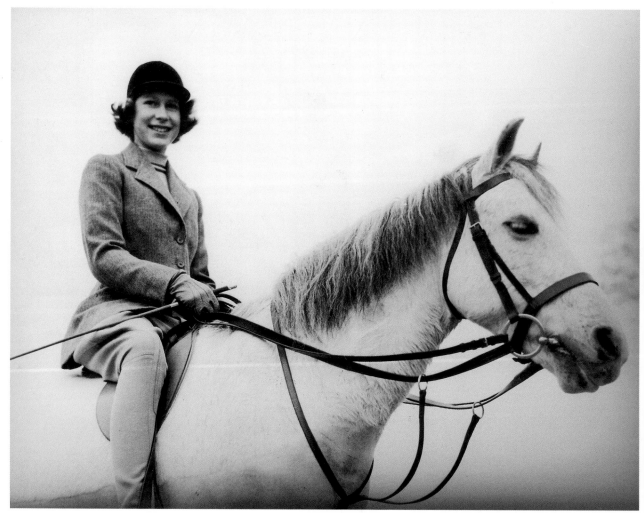

© GETTY IMAGES

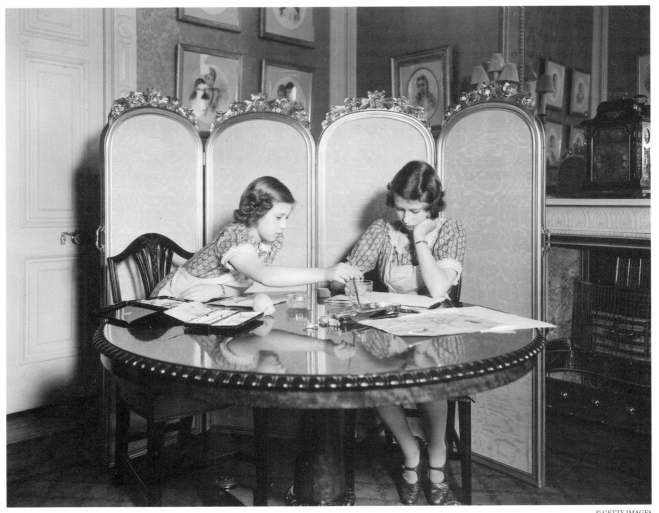

PRINCESS ELIZABETH WITH PRINCESS MARGARET

1941 and 1942

The Second World War was making life more hazardous by the day. Illustrations of the Royal Family carrying on in testing circumstances provided their subjects with a tinge of comfort. News and views of the young princesses were always sought after. Seeing them within their domestic environment, pursuing hobbies and interests helped break through the mists of royal mystic such as it existed then.

Studio Lisa's achievements in this respect gave startling evidence that the King and Queen's children went about private life in a manner not so far removed from those of a similar age in the suburbs and beyond. In a scorching July, Lisa and Jimmy Sheridan found themselves recording the royal sisters in the grounds of Windsor Castle with their mother Queen Elizabeth. Months later, as the year drew to its close in December 1941, the photographers were recalled once more to Windsor. On this occasion they were to capture the staging in the Waterloo Chamber of the pantomime *Cinderella*. In this Princess Margaret played the title role to Princess Elizabeth's Prince Florizel.

It would be April 1942 before the Sheridan's met with the Royal Family again. Royal Lodge was the setting, marking for Lisa and Jimmy their last visit to this particular residence until after the Second World War. Images registered at this time included interior portraits in the saloon, the royal sisters as Girl Guides, followed by those depicting the King and his family actively engaged in stirrup pump drill which was part of the National Civil Defence programme.

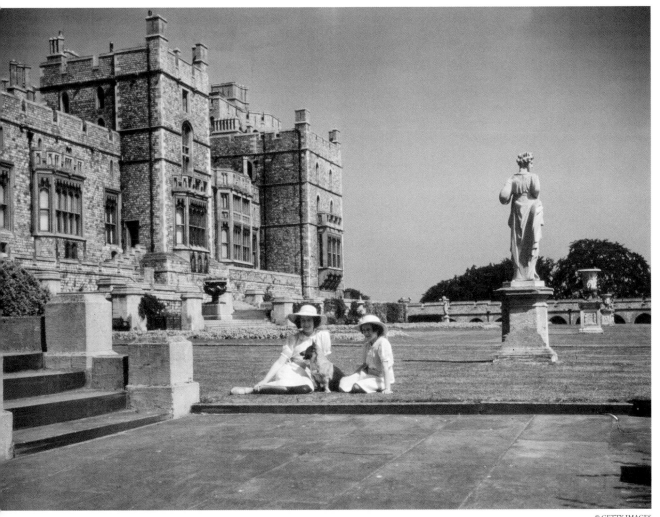

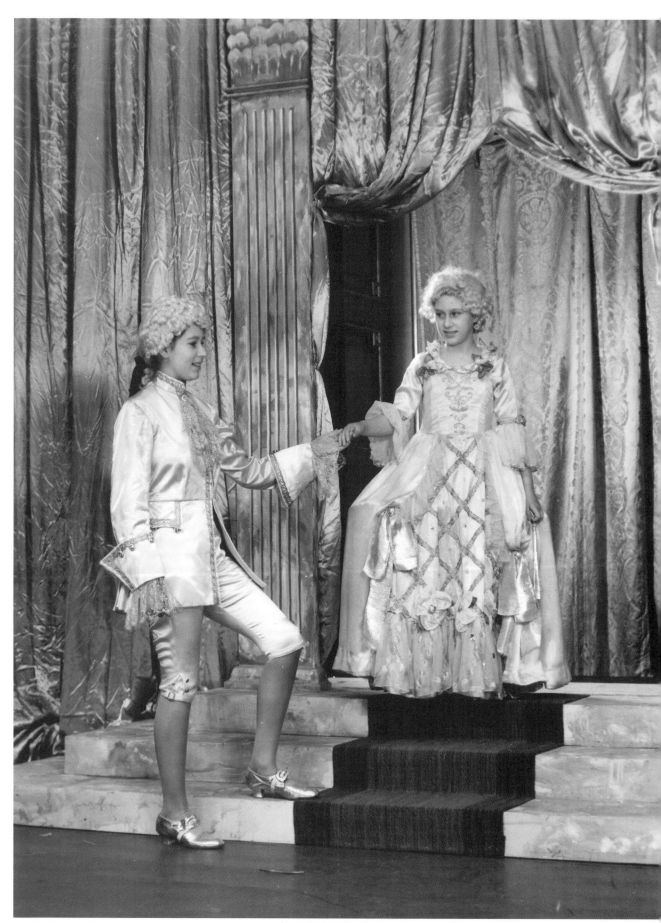

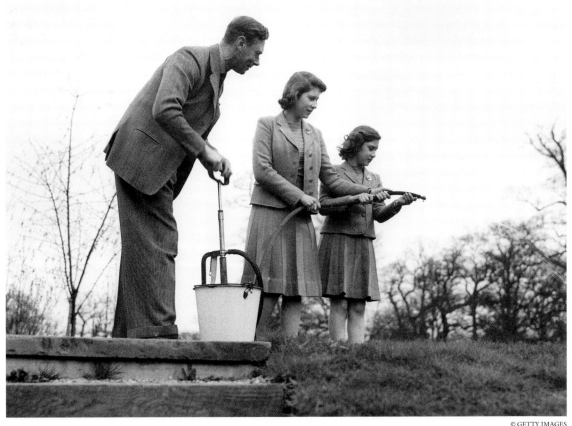

PRINCESS ELIZABETH

1944

In a series of studies taken in May 1944 Studio Lisa followed 18-year-old Princess Elizabeth around and within her own home environment at Windsor Castle. She is joined here by Princess Margaret, aged 14. Together they had ended the previous year by appearing in the Windsor pantomime *Aladdin* and are shown in their roles to the right of the photograph depicted here. This theatrical experience was still being happily recalled with the photographers six months later.

Now, during the spring that followed, the sisters are shown enjoying a ride in the 1875 French pony cart once owned by Danish-born Queen Alexandra and caring for their dun-coloured Norwegian half-brother foals Odd and Rolf. Princess Elizabeth is featured individually in her own sitting room at the castle. As Lisa Sheridan noted, this was the heiress presumptive's own personal refuge made more restful by its off white and gold furniture with pale pink and cream upholstery. The overall effect was offset by hangings featuring bouquets of variegated flowers in pastel shades which gave a lighter, brighter look, more suited to the youthful princess.

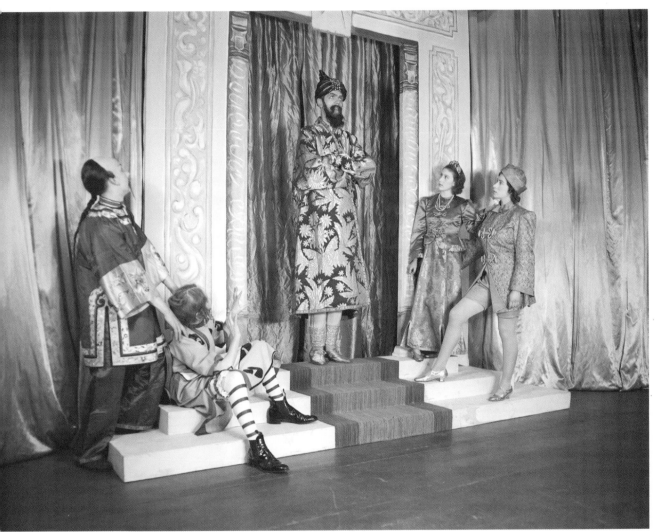

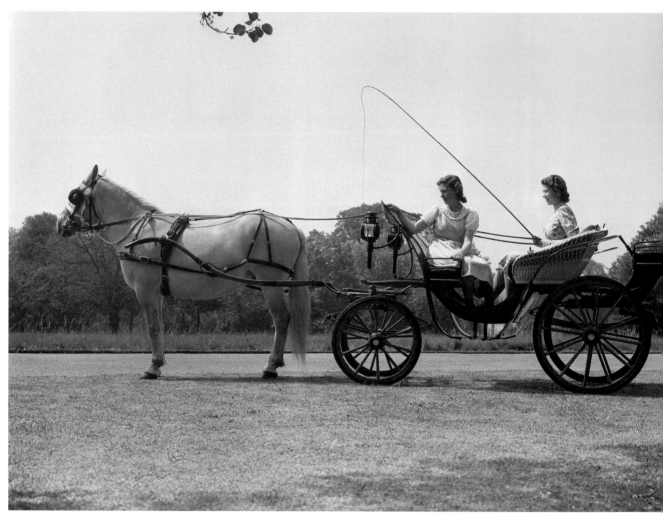

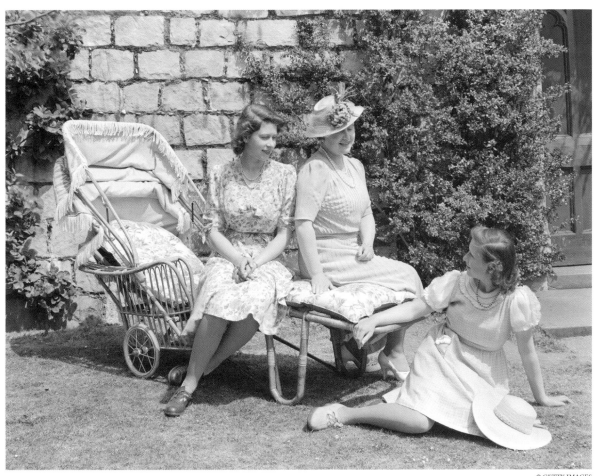

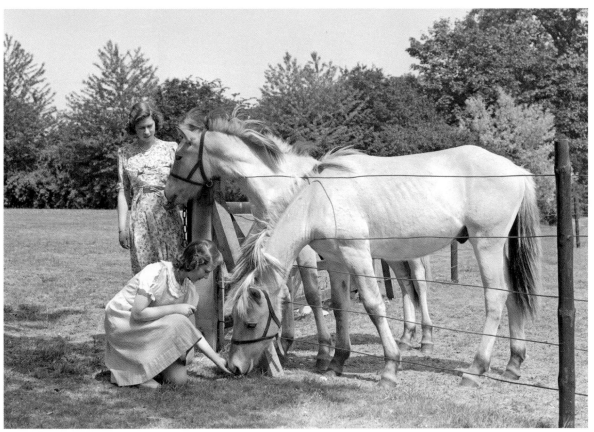

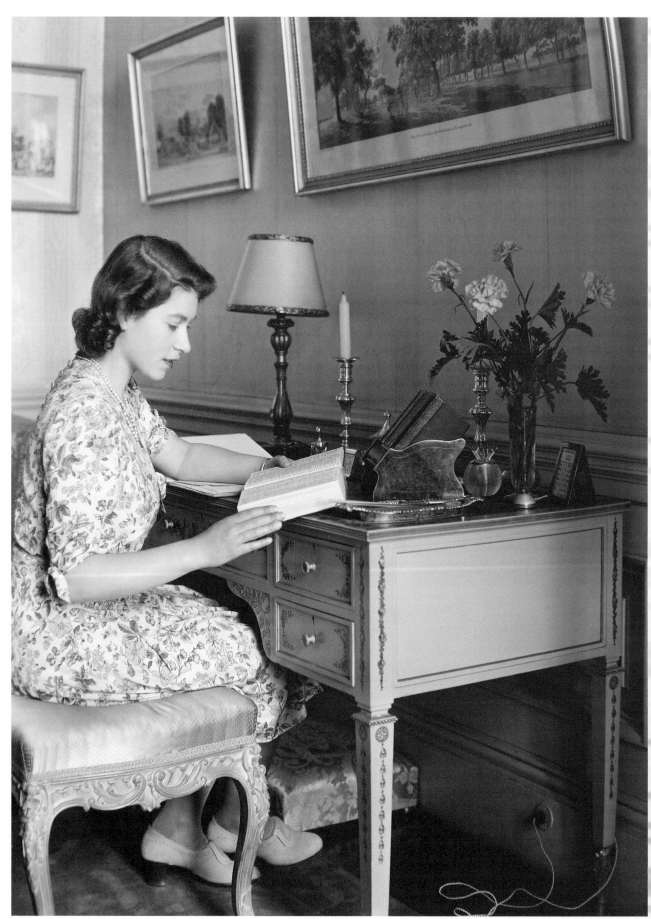

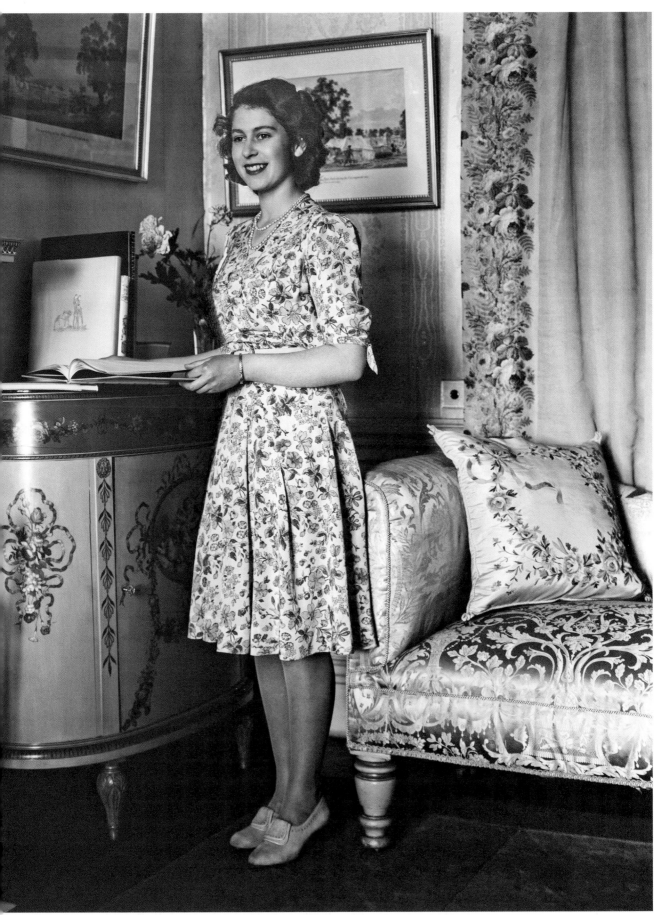

PRINCE WILLIAM AND PRINCE RICHARD OF GLOUCESTER

1942, 1944 and 1952

During the month of August 1942, Studio Lisa's cameras became focused on the activities of 9-month-old Prince William of Gloucester. It was to his parents home Barnwell Manor in Northamptonshire that the Sheridans were invited to meet the Duke and Duchess of Gloucester, their young son and Nurse Lightbody who watched over him. Nurse Lightbody would, in time to come, oversee the early years of Prince Charles in his nursery at Buckingham Palace.

The Gloucesters had four lively Australian Terriers as pets. One of them, called Zalie, had a particular fondness for Prince William. Another pet, Betty the parrot, made herself known to all visitors. She appeared to have a constant eye on the young prince as well. Whenever he was seen she'd squawk a cheery 'Hello William.'

Queen Mary couldn't help drawing attention to Prince William's flaxen hair and peaches and cream complexion. She likened her grandson's appearance to that of his grandfather King George V when he was the same age.

Prince Richard, born in 1944, eventually acquired his own favourite Australian Terrier known as Digger. This is perhaps not surprising owing to his father's tenure as Governor General of Australia during the mid 1940s.

On the last occasion that the Sheridans were asked to Barnwell in June 1952 it was to capture both Prince William and Prince Richard aged 11 and 8 years of age respectively. They specifically requested pictures of themselves in a small rowing boat on Barnwell's artificial lake.

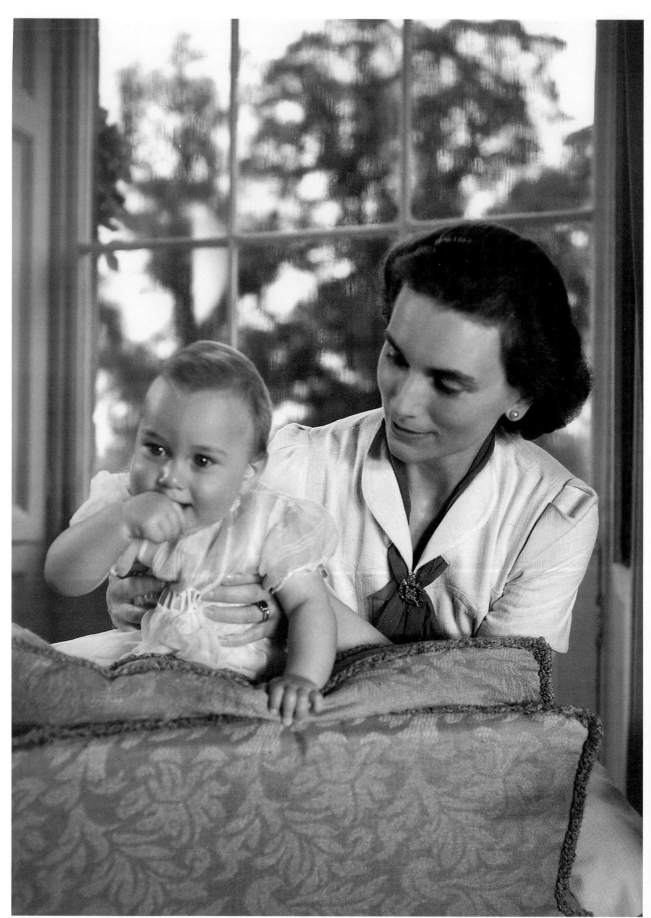

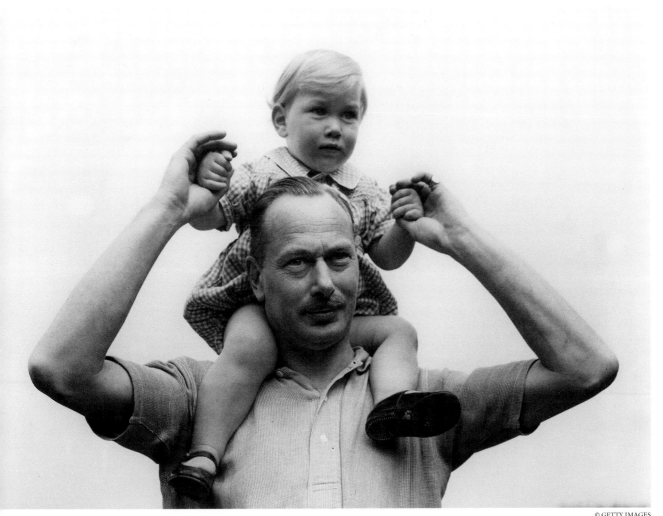

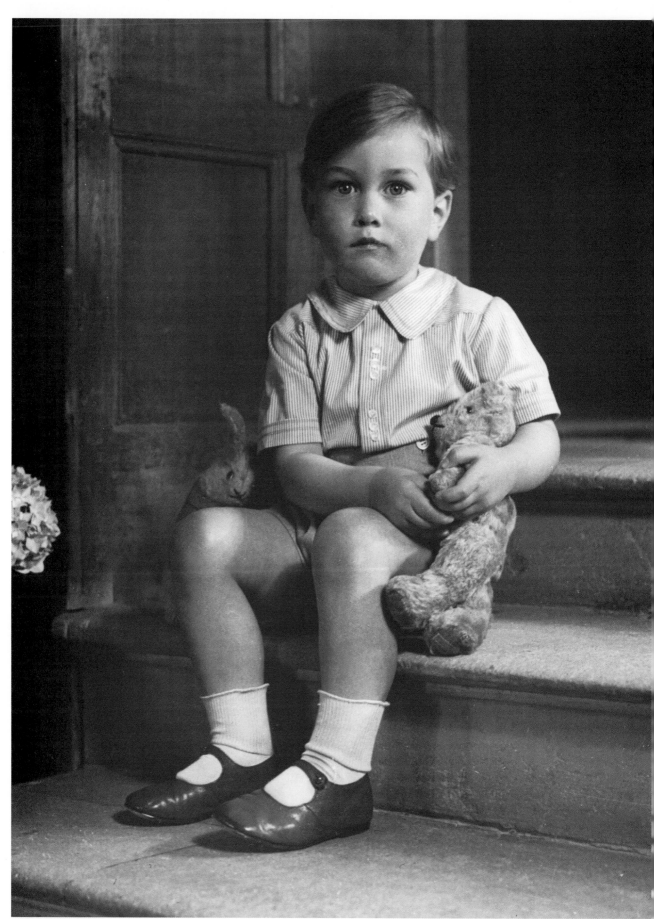

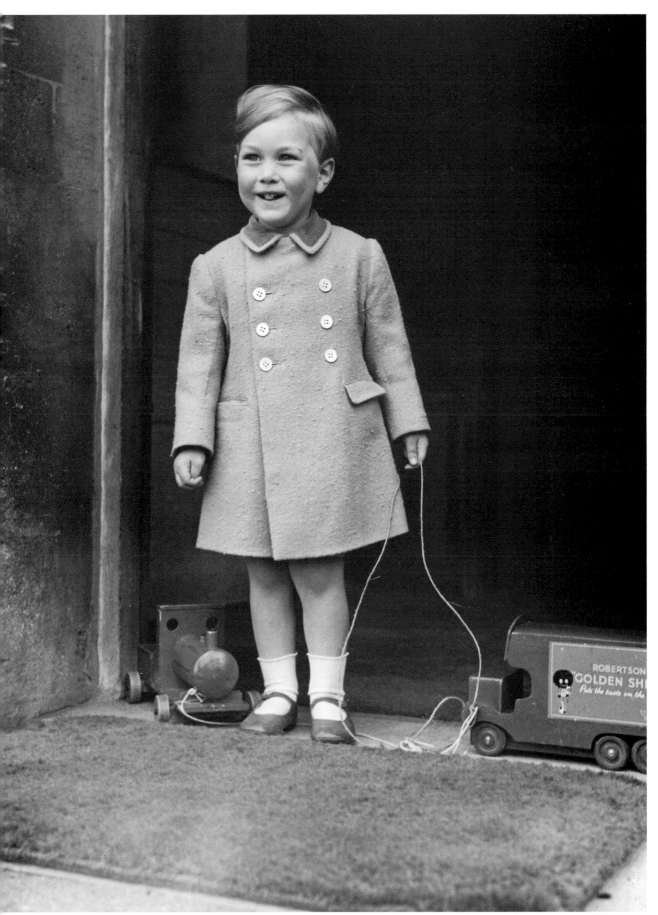

THE KING AND QUEEN WITH THEIR DAUGHTERS

1947

It was less than fifty years since the end of the Victorian era when Studio Lisa released its latest royal studies. They showed the Royal Family at this period so vastly changed, so less formal in such a relatively short space of time, that Queen Victoria might well have felt that a wry smile was finally warranted.

Comradeship, an obvious appreciation of each other and a new type of freedom. These things and more were beginning to typify the home lives of the monarch, his wife and their two daughters. Lisa and Jimmy Sheridan were two of the limited few who were privileged to see first hand what made the Royal Family tick in private. Theirs was an insight held secure by trust. Enjoying favourite dogs, horses, music, books and gardening were the nuts and bolts that made up the private world of King George VI, his Queen, Princess Elizabeth and Princess Margaret. They could simply be themselves with the Studio Lisa team.

People at home and throughout the Commonwealth, war-weary and vulnerable, welcomed the notion that their Royal Family did in fact have a life away from public scrutiny and ceremonial occasions. Such a revelation, so casually defined in a visual sense, nearly halfway through the twentieth century, achieved a great deal in breaking down the mystique that for so long had surrounded the first family in the land. With the Second World War behind them, images of the Royal Family's united front acted as a beacon of hope for what lay ahead and drew huge public approval.

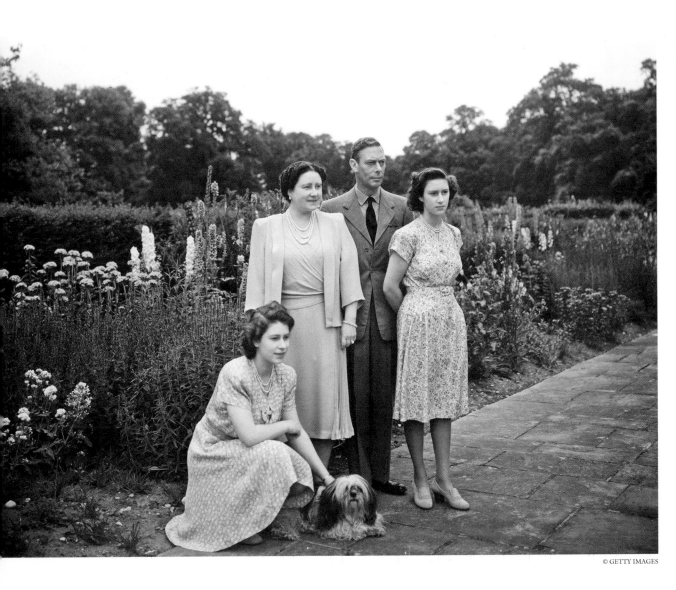

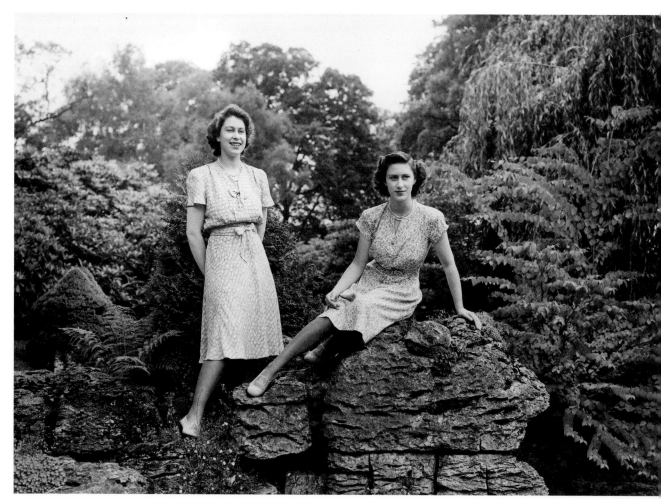

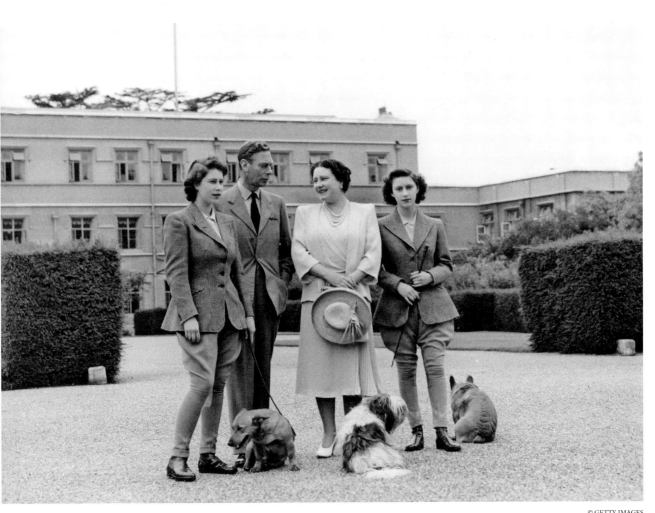

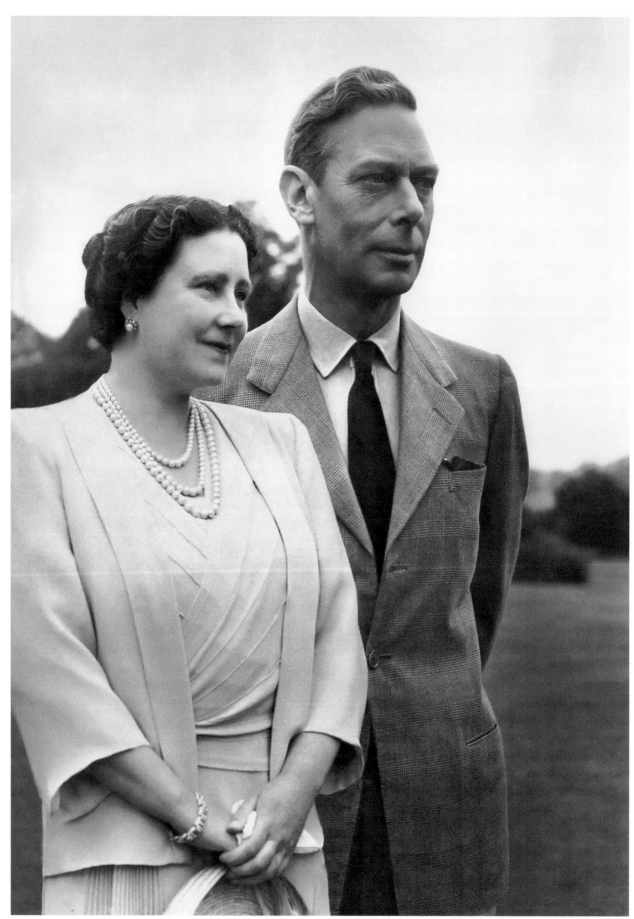

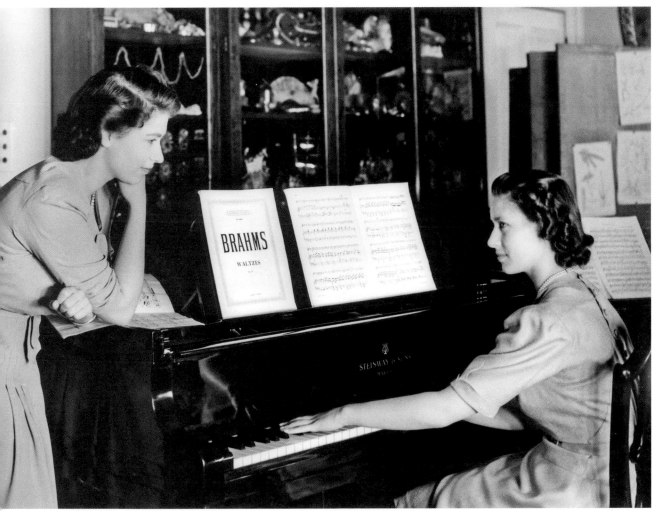

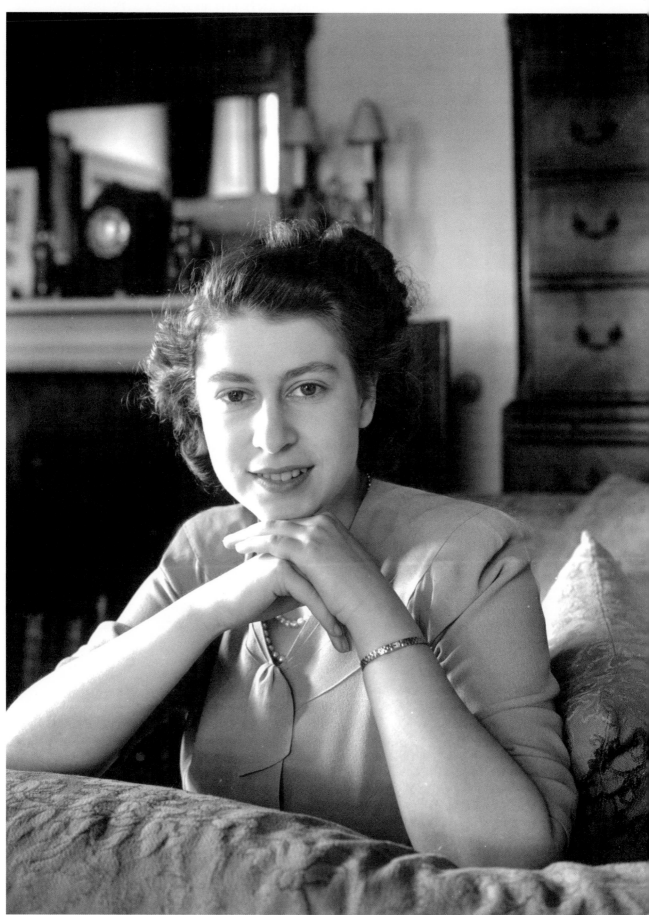

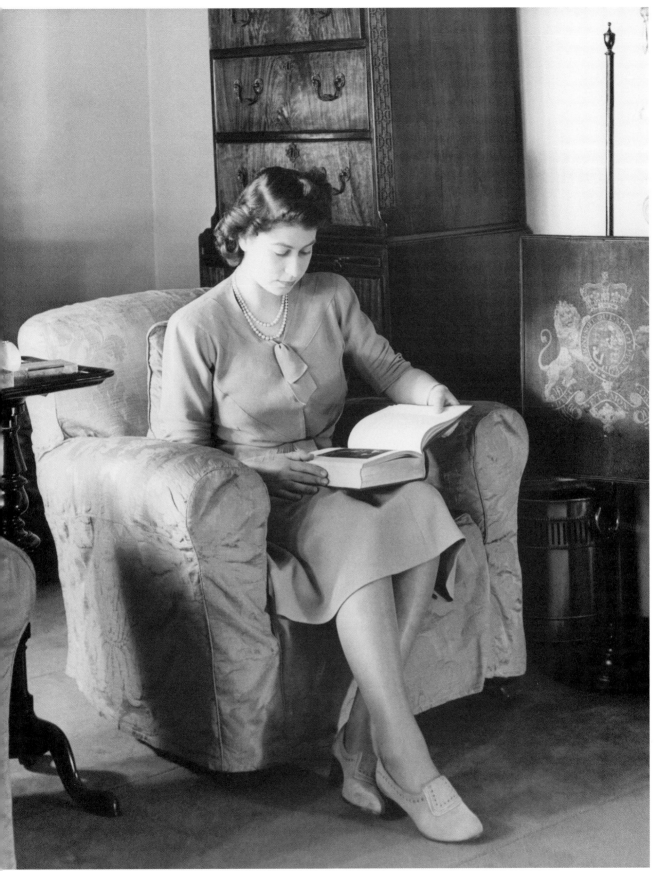

QUEEN ELIZABETH II WITH HER CHILDREN

1952

A Scottish autumn at the beginning of a second Elizabethan reign. Lisa and Jimmy are inland from Aberdeen, beside the River Dee, at Balmoral Castle. In residence we find the yet-to-be-crowned Queen of England, her husband Prince Philip, Duke of Edinburgh and their two children, Prince Charles, soon to be 4 years of age, and 2-year-old Princess Anne. They are all very relaxed in surroundings defined by Queen Victoria that are much loved to this day by her descendants.

The little prince in his pedal car is somewhat preoccupied by a white fluffy glove puppet, which he draws to his mother's attention, and which happens to remind him of Harvey, his real-life pet rabbit. Princess Anne is eager to attract attention toward her pram and what is reclining within. She showed signs of a particularly independent nature, while both youngsters between them exhibited a good deal of boundless energy to the visiting Studio Lisa pair. Brother and sister clearly enjoyed things that moved along on wheels, hence the favoured pedal car and doll's pram. Lisa Sheridan later wrote that the children's father enjoyed joining his son to play with a clockwork toy car collection and those that were radio-controlled. From her visit to Balmoral, the photographer pens a quaint insight into the personality at this time of Prince Charles, the young heir to the throne.

From what she gathered, Her Majesty's son had no concept of his importance in the realm, sharing as he did with other children of his own age a certain sense of awe and intrigue for kings, queens, and princes as depicted in storybook detail. The Queen selected a favourite image from this series of illustrations to appear on the front of her personal 1952 Christmas card.

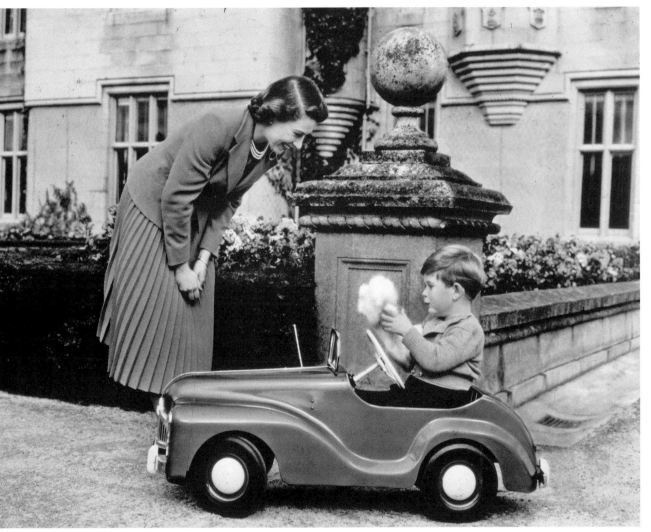

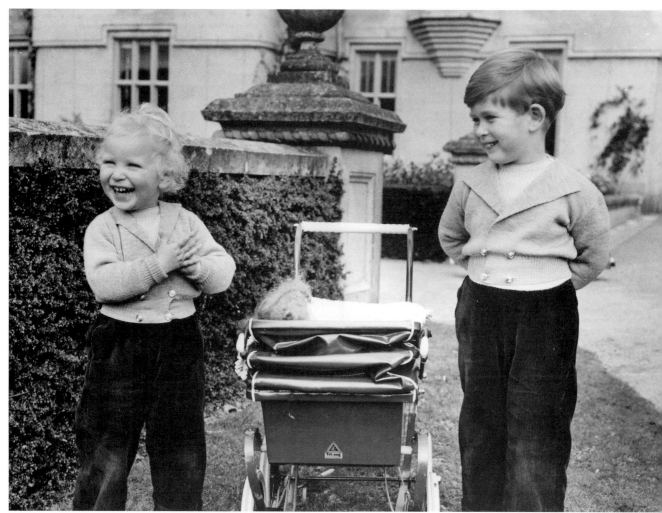

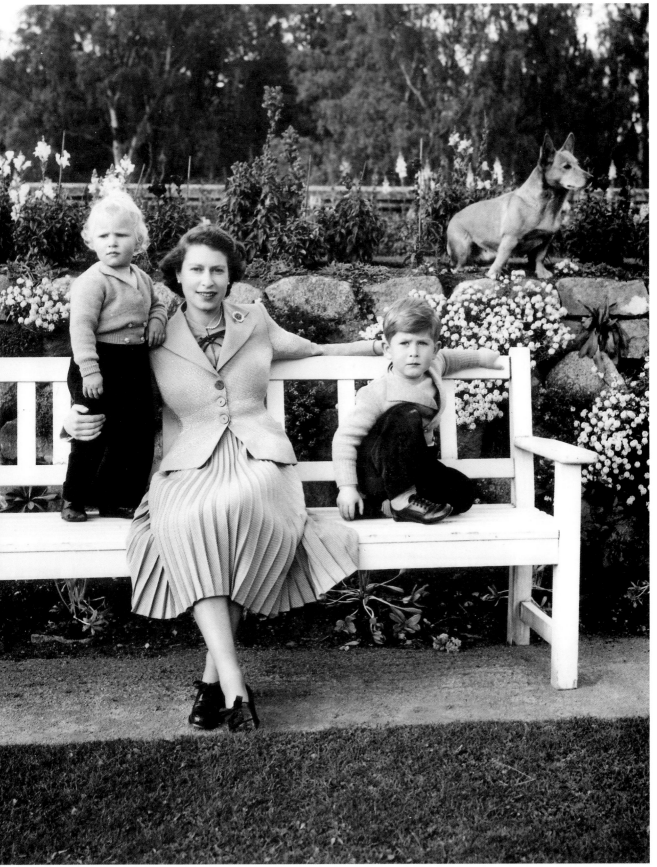

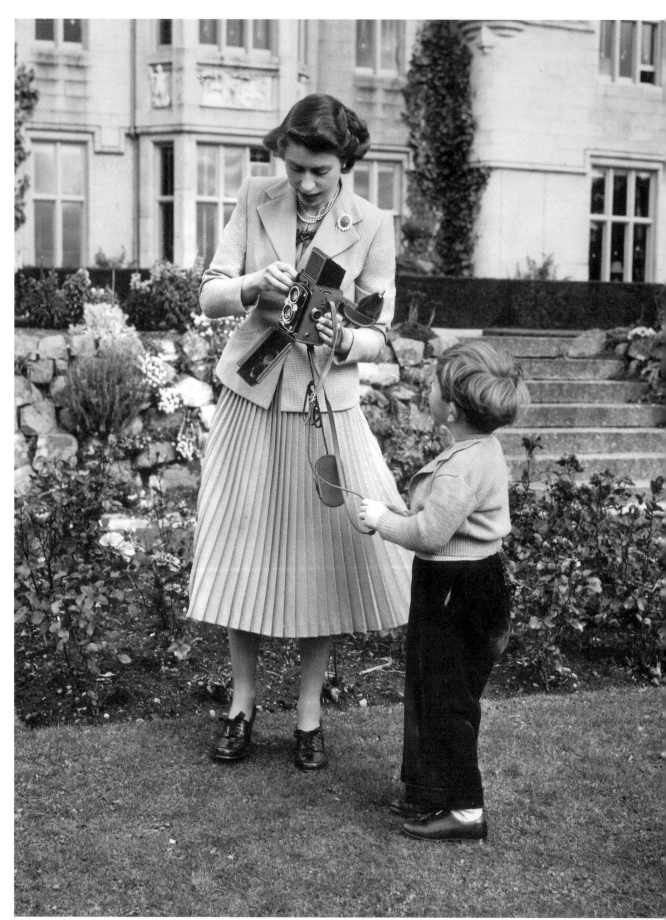

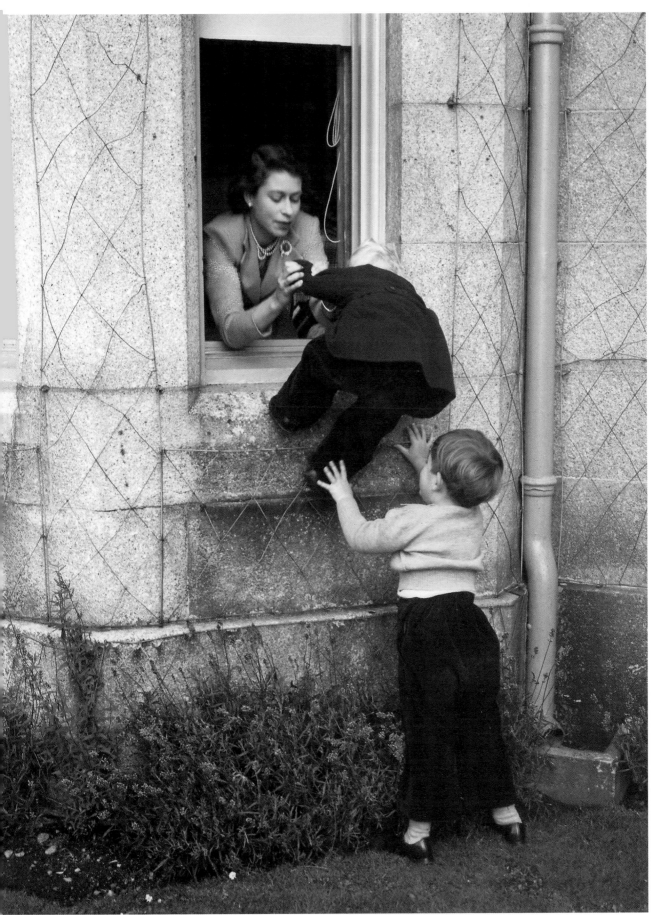

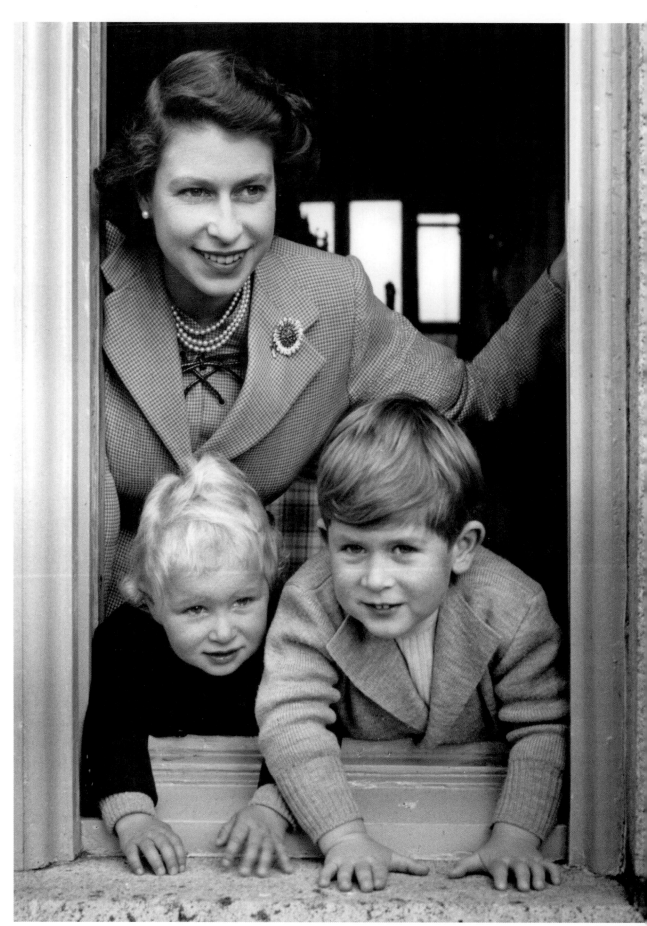

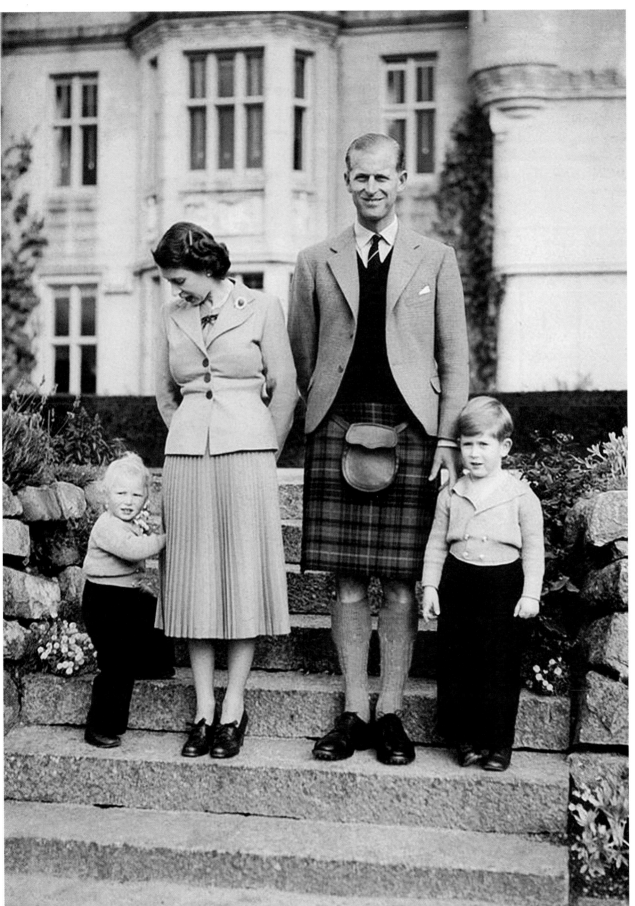

THE QUEEN MOTHER AND HER GRANDCHILDREN

1954

Towards the end of her Coronation year 1953 Her Majesty Queen Elizabeth II and His Royal Highness Prince Philip embarked on a five-month tour of the Commonwealth. During their time away Prince Charles and Princess Anne were watched over by their grandmother.

It was a beautiful spring day in April 1954, just one week before the children's parents were due home, that Lisa and Jimmy Sheridan were invited to Royal Lodge. The Queen Mother wanted photographic mementos of what had been a very special period for her with her grandchildren. The three of them were devoted to each other then, just as they would remain with other grandchildren to come, throughout the Queen Mother's long life. For Prince Charles the opportunity of being in his grandmother's company was always rewarding. It was never long enough. They had a special affinity which endured down through the years.

The Studio Lisa cameras recorded the young brother and sister playing in the grounds of Royal Lodge just as their mother and her sister, their

aunt Margaret, or 'Margot' as they called her, had when they were young. The children's grandmother had kept them fascinated with stories related to their mother when she had been the same age. For the Sheridans this assignment had a special poignancy. As they set up their cameras to capture the prince and princess at 'The Little Welsh House' reminders of how, almost two decades before, during their first visit to Royal Lodge they had photographed the Duke of York and his family in the same setting. No one could have imagined then what the hand of fate had in store.

When the Queen filmed her first televised Christmas message to her subjects in 1957, the Sheridans noticed, with a justifiable sense of pride, that prominently displayed alongside Her Majesty on her desk was a framed Studio Lisa photograph of the monarch's children amidst the Royal Lodge daffodils from three and a half years before.

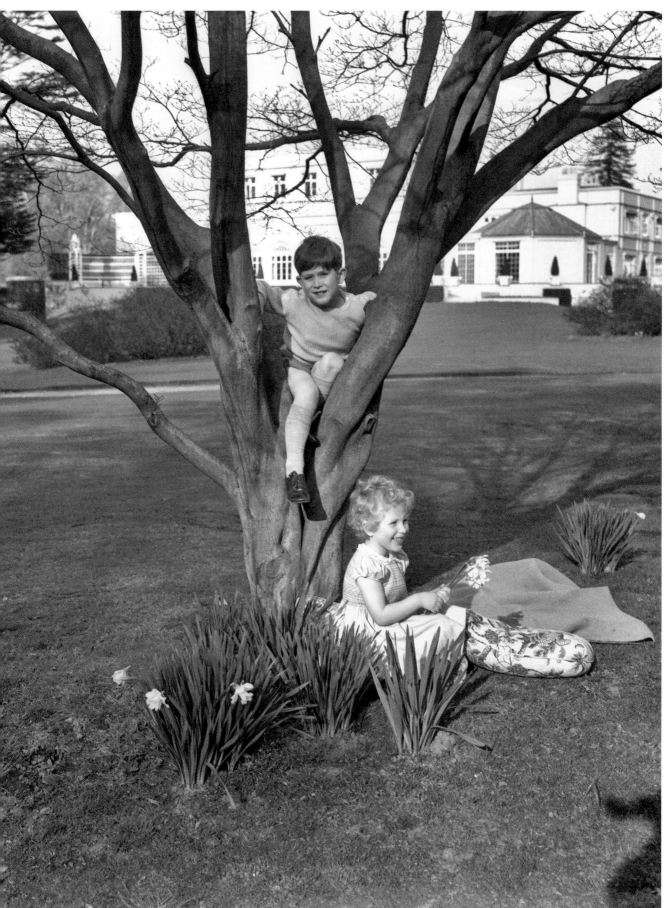

QUEEN ELIZABETH II AND PRINCESS ANNE

1959

A new series of Studio Lisa images featuring Queen Elizabeth II and her 9-year-old daughter Princess Anne were commissioned during a warm spell of weather in the last summer of the mid-twentieth century. Backgrounds chosen included the gardens of Windsor Castle. Red and yellow roses climbed ancient stone walls behind our royal mother and daughter, who are featured in summery frocks befitting the more casual approach to this particular photographic session.

The scene then moves nearly one mile away to Windsor Home Park and the grounds of Frogmore House. Frogmore dates from 1680 and is so called because of its frog fraternity that has traditionally existed there thanks to the watery marshlands that are part and parcel of the local terrain. Here the Queen and Princess, now kitted out into full riding attire, are captured with Princess Anne's horse Greensleeves and her corgi Sherry. Sherry's mother happened to be Sugar, the Queen's Welsh canine favourite who also appears in some of the camera settings.

Other Frogmore scenes include a summer house known as 'The Ruin'. This faces an artificial lake where a blue dingy is tied up for the Royal Family of the day to enjoy when they wished.

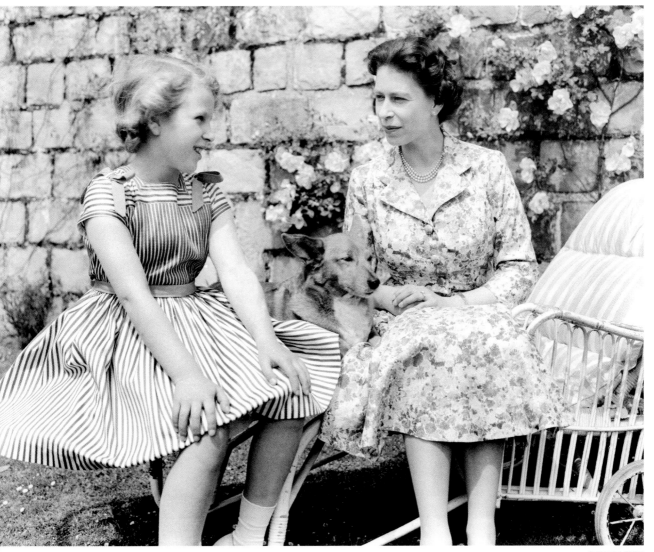

THE QUEEN MOTHER'S 60TH BIRTHDAY

1960

In August 1960, Queen Elizabeth The Queen Mother celebrated sixty years of an already remarkable life. Included in the events to mark this occasion, Lisa Sheridan was invited to Clarence House with her camera. It was the photographer's first visit to this royal residence built by John Nash between 1825 and 1827.

Lisa regretted so much not being able to share such a new experience with her husband Jimmy, who had died two years previously. It was the Queen Mother's personal request to have these birthday photographs recorded in her own London garden. She had moved into Clarence House with her younger daughter Princess Margaret following the passing of her late husband King George VI in 1952. The previous occupants had been Princess Elizabeth and the Duke of Edinburgh together with their young children Prince Charles and Princess Anne, who was born there in 1950. That family of four then took up residence down The Mall at the new, young sovereign's official headquarters Buckingham Palace. Queen Elizabeth The Queen Mother remained living at Clarence House as her recognised London residence until her death in 2002.

© CAMERA PRESS

© CAMERA PRESS

151

QUEEN ELIZABETH II WITH PRINCE ANDREW

1962

The charming spontaneity of the energetic little prince with his mother in this July 1962 series is as captivating today as it was at the time of their taking. Immensely popular, the photographs captured the public's imagination around the world. Reviewers everywhere were ecstatic and universal praise for her work was heaped on Lisa Sheridan. The outdoor setting is Windsor Castle, now so familiar to Studio Lisa. Interior studies, though, were taken in the toddler's nursery at Buckingham Palace, where the celebrated shots of Prince Andrew popping up from behind the settee were taken. Lisa referred to these as the 'peek-a-boo' scenes; they were, she said, her personal favourites.

After the Queen's approval, in September 1962 the New Zealand High Commissioner in London obtained a selection of ten differing prints of Prince Andrew from this sitting. From them, two poses of the little prince were chosen to appear on New Zealand health stamps for the following year. Design proofs were ready for approval in February 1963 when the Queen and the Duke of Edinburgh were on tour in New Zealand. Subsequently, proceeds from the sale of The Prince Andrew 1963 Health Stamps were donated to the children's health camp movement originally set up in New Zealand in 1919.

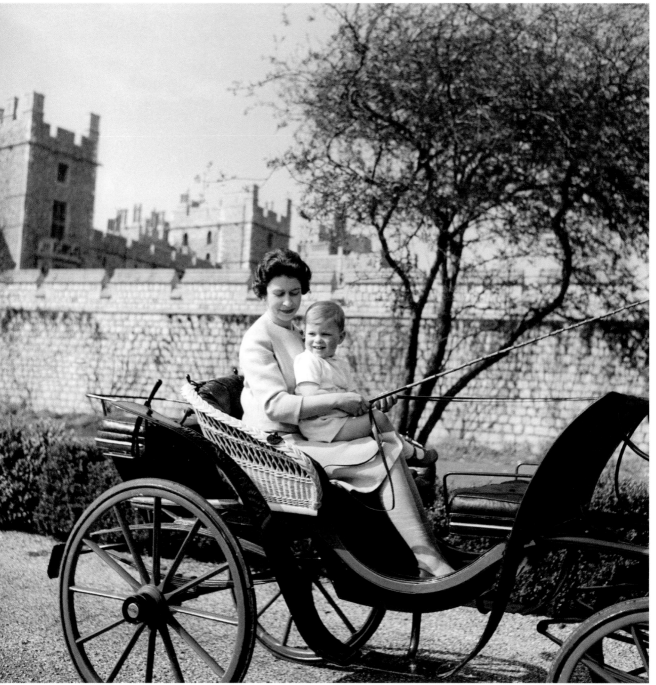

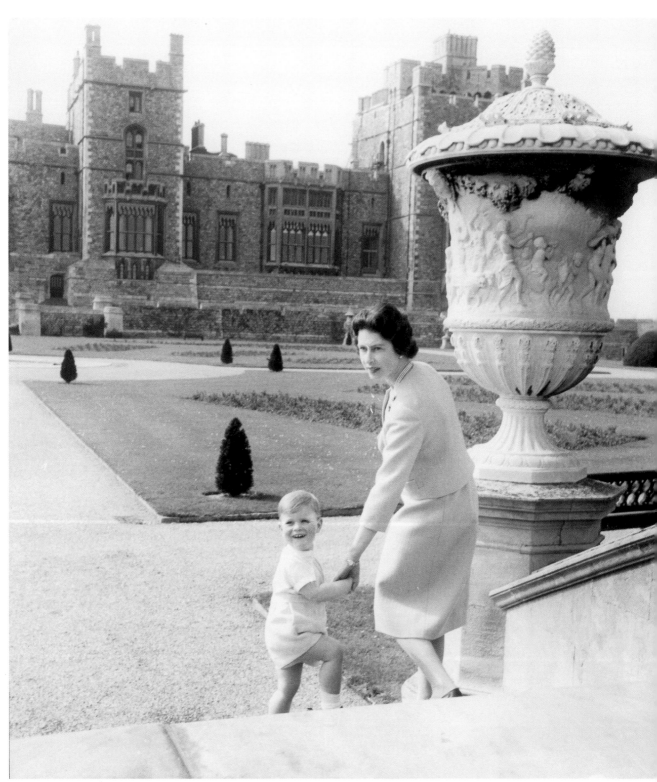

PRINCE EDWARD AS A BABY WITH HIS MOTHER QUEEN ELIZABETH II

1965

Following his birth on 10 March 1964, Prince Edward's first twelve months were marked by a small collection of photographs taken by Studio Lisa almost one year later to the day. Lisa recorded these images at Buckingham Palace. She was somewhat taken by the placid nature of this royal infant and the easy interaction between himself and his mother the Queen. In the fullness of time Prince Edward would become the first English prince since the Tudor period to be specifically created an earl rather than a duke of the realm.

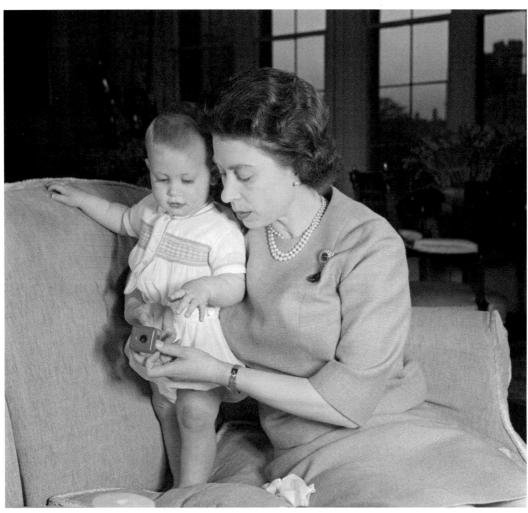

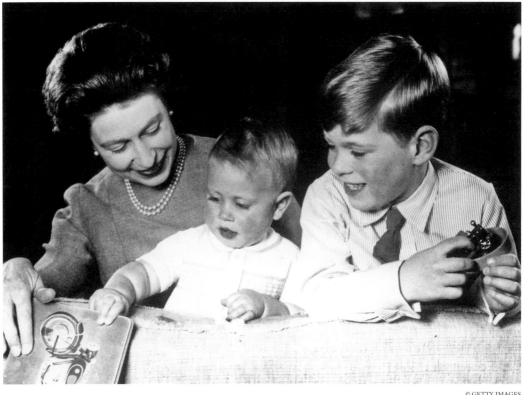

PRINCE ANDREW WITH PRINCE EDWARD

1965

On a cold overcast day in October 1965, what would be Lisa Sheridan's final royal assignment went before her camera in the autumnal gardens of Buckingham Palace. Five-year-old Prince Andrew and his younger brother, the 18-month-old Prince Edward, were to be captured playing outdoors just as spontaneously as any other youngsters of their age might do. The warmly-clad brothers were both in an exuberant mood. It took Lisa all her time to capture them in the frame of her lens as they jumped or ran from one activity to the other. The two young princes had plenty of choice. Leaves were everywhere; Prince Andrew and Prince Edward attempted to hide in them after raking them into an untidy pile. Prince Edward waved a stick with a plastic windmill attached. He was making a great effort to blow on it so the fronds turned around and round. The boys played on a jungle gym that had them climbing and clambering over its cube-shaped frame. There was also a toy lawnmower to push around, and their mother's corgis would jump into the garden's lake to retrieve their thrown sticks.

EPILOGUE

It was in March 1970 that I began the journey towards *Informally Royal*. I had ventured into Hertfordshire to knock on the front door of a house in Parkway, Welwyn Garden City. No. 14 had been the home of Studio Lisa. I was received rather tentatively by the then owner and future delightful friend Jean Tindall, who with her late husband had purchased this property from the Sheridan family. Introducing myself, I explained that as a student of photography I was fascinated by the artistry of Lisa and Jimmy Sheridan. I added that I was studying the merits of garden cities, specifically Welwyn Garden City. As a frequent house guest over the subsequent years, I came to appreciate in greater detail the environment of home, former studio and garden that had framed the background to such an amazing story.

A year or two before this event I had written, while still in New Zealand, to the *Welwyn Hatfield Times* seeking a correspondent to share notes on my own country compared to that of Welwyn Garden City, its history and future development. My respondent, with whom I am still in touch, coincidentally also lived in Parkway. Her father, a keen cameraman, eventually went on to photographically record the demolition of the former Studio Lisa site when, in the early 1980s, it was sold to a group of accountants. Whilst retaining the red-brick front facade, the new owners of 14 Parkway chose to redesign the original interior beyond recognition. The studio and attractively planned rear garden that had survived since the 1930s were totally destroyed in favour of extending the main house. All that remained, was the rustic, ornamental pond watched over for fifty years by a large plaster-cast frog. It now sits on a favourite rock looking out over my own rural pond in New Zealand.

Studio Lisa, with its royal associations, will always be synonymous with Welwyn Garden City. Whenever the town's history is illustrated in time to come, a spotlight will inevitably fall on the Sheridans' photographic record of the garden city's expansion during their residency. It is indeed my earnest wish that *Informally Royal* will be a fitting addition to the archives of Welwyn Garden City history and, as a consequence, be enjoyed long into the years ahead.